Dear Mike.

It's still Terribly
difficult Oh god. "

Hope this makes
a bit easier

love,

Johnnie.

THE MAGIC OF
WATERCOLOUR

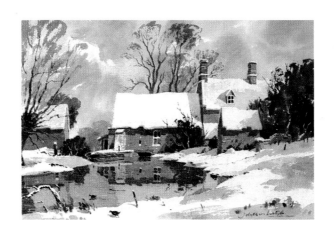

Dedicated
to my wife Gill
whose constant help over my painting and
writing work I could not have done without

By the same author:
Water-colour painting landscapes and townscapes (1982)
Subject and place for watercolour landscapes (1985)

THE MAGIC OF
WATERCOLOUR

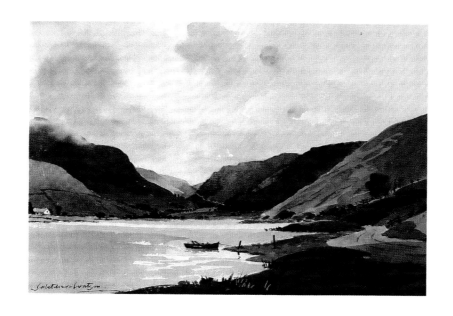

JAMES FLETCHER-WATSON
RI, RBA

B.T. BATSFORD LTD. LONDON

Printed 1988, 1989, 1990, 1991, 1992, 1994

ISBN 0 7134 5514 4

Printed in Hong Kong by
Bookbuilders Ltd
for the publishers B.T. Batsford Ltd
4 Fitzhardinge Street, London W1H 0AH

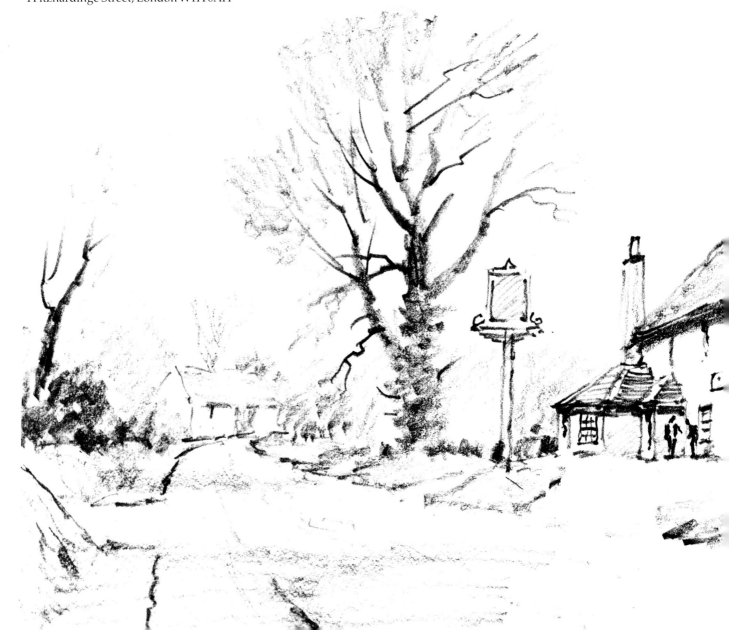

Contents

Preface

At last I have been given the chance to write a book on watercolours with virtually no restrictions on the number of colour illustrations. This has meant that the whole task of passing on ideas and methods, showing how to paint in this elusive but most exciting medium, has become much easier and I think this book will add a new dimension to my previous books. I can now explain to my painter friends and students, step by step, how a watercolour landscape picture develops, showing in separate colour prints the *first stage*, the *middle stage* and the *final stage*. I can have in colour a page showing many actual colour mixes, and this mixing of colours is a most important part of the process. And I can demonstrate with *studies* in colour, details of tree painting, architectural details and how to paint water and reflections and so on.

I am making the book a series of question and answer chapters on all the main items one meets with when painting landscape – skies, foregrounds, distance, trees, water, mountains, buildings and so on – and you will be able to use the book to look up something you want quickly. I hope, of course, that you will first read the book right through.

At the beginning I am including colour illustrations of five of Britain's early great master watercolour painters as a useful reminder of the wonderful work they did and of the great watercolour tradition we follow. I personally find it a great help and inspiration to look at these early painters' work from time to time. They all painted on the spot out in the open as well as in their studios and I want to encourage you to do the same, especially painting out-of-doors.

To paint a really good watercolour you have eventually, of course, got to get away from copying someone else's way of painting and find your own way of doing things. You will discover on your own the subjects that most excite you and be able to recognize the type of light and colour and tone which gives you the sort of subject you really long to paint and put down on paper in clear transparent washes. That is what this book is all about – to help you to produce beautiful watercolour pictures yourself as you have never done before.

Foreword

The author of this book is a watercolour painter who used to be an architect as well. This means he has been trained to observe, analyse, evaluate and depict what he sees before him. It means also that he is always aware of the structure beneath the surface, of such qualities as thickness and weight, of balance, texture and movement. (Let no one believe that a building stands still and is therefore easy to draw.)

Such professional knowledge of course opens some doors but closes others. It can, as Ruskin discovered, lead to no more than a dry catalogue of visual facts. It can stifle passion, restrict imagination, suppress lyricism. Not so here. The artist's choice of subject may sometimes appear to be unadventurous, but its portrait – whether of a tree or a mudflat or village street – is always interpreted with a true love and understanding of what is there, while the generous advice given throughout on materials, techniques and other practical details is always laced with an enthusiasm that almost crackles off the page.

James Fletcher-Watson obviously enjoys every minute of what he has called the magic of watercolour and he conveys his enjoyment to all of us.

Sir Hugh Casson, C.H., K.C.V.O.
Past President of
The Royal Academy

1 The early master painters in watercolours

In this chapter there will be no attempt to trace the whole history of the English watercolour school, which started in the middle of the eighteenth century; instead I have chosen five examples of the really good painters who began this tradition so that we can see how the pure watercolour idea came into being.

It was not difficult to choose five painters because the ones I have selected have been my favourite watercolourists for many years and they are outstandingly superb painters; but there are so many geniuses of that period that I could easily have chosen ten or even fifteen, and all of them would have been in the top flight. These five consist of Girtin, Turner, Cotman, Cox and De Wint, and I took some time looking at various examples of their work in different art galleries before I made my final selection. I chose landscapes rather than buildings or townscapes because this book has the emphasis on the rural scene, but all these painters were extremely accomplished at painting architectural subjects as well as wild country views, and had there been unlimited space I would have shown one of each subject, rural and architectural, from each artist.

We will now examine each picture in detail together and I will endeavour to point out the characteristics and techniques of each painter.

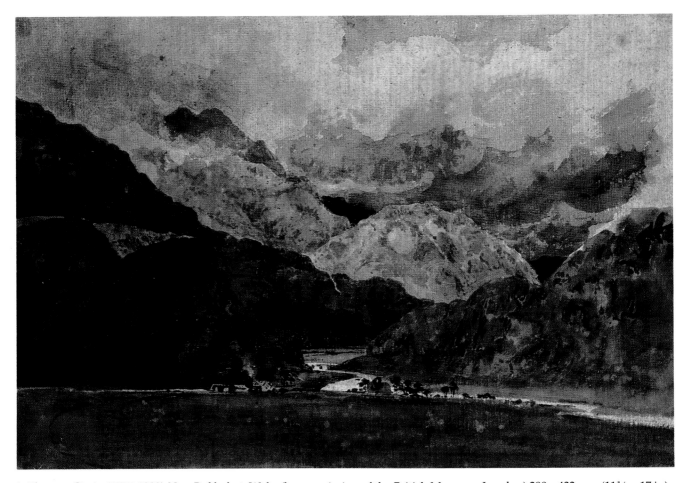

1 Thomas Girtin (1775-1802) *Near Beddgelert, Wales* (by permission of the British Museum, London) 290 x 432 mm (11½ x 17 in)

Thomas Girtin
(1775-1802)

Near Beddgelert – Wales

This lovely picture was painted by Girtin in 1798 when he was 23 years old. (He died at the very early age of 27.) He was almost the first artist to use light washes overlaid by darker washes without losing transparency; in other words he was the earliest watercolour painter to use the *wash style* or *wetlook*, as it was sometimes called.

It is interesting to note that the firm of James Whatman produced in the 1780's a beautiful new type of watercolour paper called 'wove' paper which had an even but textured surface with the right type of absorbent quality. It also had a sized finish which enabled the painter to lift colour off with sponge or brush and even scratch out without damaging the paper too much.

I have closely examined this Girtin picture at the British Museum and the texture of the wove paper is delightful and would obviously be very conducive to watercolour.

Earlier papers were known as 'moulded' papers and there was a pattern of lines left on them, which was not so satisfactory as the new wove paper.

It is always difficult to tell whether a picture has been painted on the spot or in the studio but I think this one, near Beddgelert, was most probably painted in front of the subject as there is a certain careless dash about the picture when viewed closely. Girtin exhibited the same subject (but a different painting) at the Royal Academy in 1799 and he almost certainly copied it from his on the spot sketch.

The colouring is typical of Girtin – blue-greys and browns. I think that is why he was so fond of going to Wales, where the weather is so often cloudy and the autumn colouring just as he has shown here. In fact Girtin nearly always painted in these rather sombre colours; he never opted for bright blues and greens and reds, even in his building subjects.

Today we have the opportunity to visit lovely exhibitions of paintings by famous watercolour painters, with beautifully illustrated catalogues and learned discourses on the characters of the painters and where they went to paint; but very seldom do they give the one thing that painters like you and I really want to know – namely *what colours* the artists used. After much research I have managed to find out that Girtin used the following – Yellow Ochre, Burnt Sienna, Light Red, Monastral Blue (the modern equivalent is Cyanine Blue) and Lamp Black – which explains very well the general colouring of his pictures as we know them. I should add, however, that very recently I read an article in an ancient copy of *The Studio* magazine dated 1903, by Walter Shaw Sparrow, and he stated that Girtin used no less than 15 colours, which included the ones I have mentioned but also some rather bright colours like Gamboge Yellow and Ultramarine Blue. There is not much evidence of such colours in his paintings but I give this information for what it is worth.

You will notice in this picture that Girtin has captured the bright sunlight on the buff coloured mountains in the middle distance, and the effect is obtained by painting the high mountains behind a very dark tone which could be a mixture of Monastral Blue and Black. The lower mountains and hills in front are also a fairly dark tone, probably a Monastral Blue and Burnt Sienna mix.

The highest mountain left of centre is emerging from cloud, and this has been achieved by painting dry into wet so that the part of the mountain below the peak, which was painted with a stiff almost dry mix, has blurred and run into the wet grey mix of the low cloud.

Girtin has given texture and modelling to the mountains by using a small brush and dry brown paint; some of this work consists of short lines and dots, as if drawn with a pencil; this is a typical technique of Girtin's.

The wove paper used has a definite tone of a light biscuit colour, and he generally used toned paper which of course tends to give a delightful mellow effect to a picture.

Girtin's draughtsmanship was superb and there are many examples of his architectural work. The Whitworth Art Gallery, Manchester, has his picture of Durham Cathedral, and it appears that little pencil-work was used but simply broad washes of colour and then architectural detail filled in by using the point of a small brush with brown paint.

Girtin worked at Dr Monro's famous establishment in London where he met Turner and was a very considerable influence on him in his early years.

What we can learn from Girtin is good composition and simplification of the subject: broad simple washes and atmospheric effect, especially in his mountain pictures, with gleams of sun and dark cloud shadows.

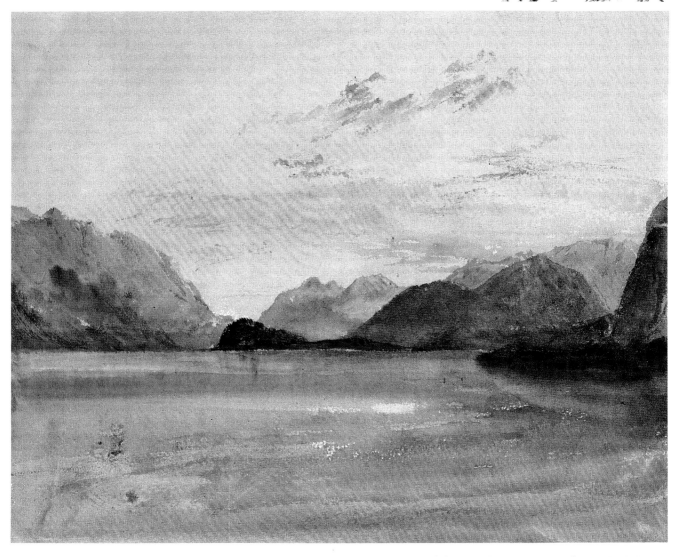

2 Joseph Mallord William Turner (1775-1851) *On Lake Como, Italy* (by permission of the British Museum, London) 230 x 310 mm (9 x 12 in) approx

Joseph Mallord William Turner (1775-1851)

On Lake Como – Italy
Turner is undoubtedly one of Britain's finest landscape painters in both oil and watercolour. He was almost entirely a watercolour painter for the first 20 years or so of his life. His versatility and style changed all through his life, according to the requirements of the subject, but also owing to his rapidly developing skill. His very early paintings were like Girtin's work; they knew each other well and worked together at Dr Monro's establishment. Girtin often drew in the outlines when copying pictures by Cozens, and Turner would fill in the colour washes.

This picture *On Lake Como* was painted in his middle-life period, probably about 1820. I found it was not easy to select just one Turner picture out of so many hundreds available at the many art galleries in Britain. There is no such thing as a typical Turner watercolour as his work is so varied, and in fact I wanted one of his wet-wash pictures and this one seemed to me a lovely example. There is distance and atmosphere, marvellous simplicity and harmonious colouring in it.

Note the design of the sky – the clouds sweeping in curves towards the left-hand pink mountain. It must be late afternoon with touches of pink in the sky as well as on several mountain tops. The lake has wet into wet washes and the blue water runs into the grey-yellow foreground shore in a pleasing loose fashion. He did not want detail on the shore to take the eye away from the centre mountain group. How daringly dark is the tree-covered small hill in the centre, giving an admirable focal point.

The blue he used for sky, mountains and water is almost certainly Prussian Blue. He would have mixed a colour like

9

Light Red with the blue to obtain the grey-blue he required. He often used his fingers with watercolours, smudging part of a damp wash, and it looks as if he has done this with the foreground here where the water meets the yellow shore. One can often detect a thumb print on his watercolours. He certainly used to scratch out for light tree branches or rough water or texture on rocks and mountains or a mountain stream seen in the distance. He grew a long finger nail specially for this purpose. He also used a knife.

Turner usually worked quickly to catch an effect of light that might change very quickly (a problem we all have to face). He cultivated no mannerisms or self-conscious techniques but just painted as fast as he could, getting the colour down on paper with rapid brush strokes. Because of his genius, those brush strokes portrayed the objects he was painting in an accurate but impressionistic way. We can feel this as we look at the Lake Como picture. How perfect the balance and composition are. We can see how direct the work is: the wash tones were right the first time and there is very little over-painting. Just the small dark hill in the centre probably got strengthened at the very end of painting. This picture has the sun coming from the right, but Turner often painted into the light with the drama of things being seen in silhouette.

The great lesson we learn from Turner is to get the statement down on paper fast and to capture the light and atmospheric effect even if it means sacrificing accurate detail. He was a painter well in advance of his time and was really the first of the Impressionists before that movement had started. He was a great traveller, painting in many parts of England, Wales and Europe.

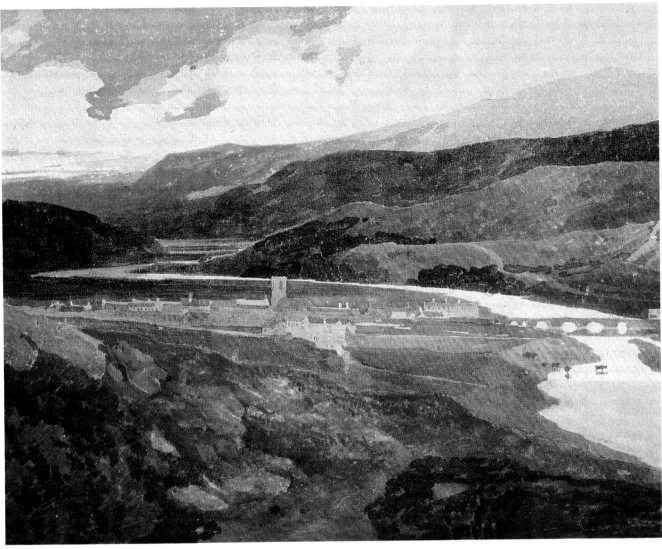

3 John Sell Cotman (1782-1842) *Dolgelly, Wales* (by permission of the Fitzwilliam Museum, Cambridge) 285 x 450 mm
(11¼ x 17¾ in)

John Sell Cotman (1782-1842)

Dolgelly, Wales

Now we come to a painter who from his first beginnings developed a style quite unique and different to any artist's work up to that time. He was definitely an innovator with his slabs of colour fitting into each other, making a beautiful harmonious pattern. He could convey detail and texture with a single wash on rough wove paper. He knew Turner well and painted at Dr Monro's, but sadly, unlike Turner who sold his pictures for high prices and died a rich man, Cotman was not recognised or popular with the public, having to sell his pictures for absurdly low prices, and dying a pauper. Today he is recognised in Britain as one of the greatest watercolour painters. He painted in oils as well and these were often masterly, but his watercolours reached the greatest heights.

I show here the picture of Dolgelly, a gorgeous Welsh mountain in a distant scene. There is so much in this picture: the twisting river, the town, the bridge, the cattle, the foreground track with rocks and shrubs and the blue distant mountains, but it is all held together into a superb composition, in Cotman's inimitable way, with his perfect tone values.

I mentioned the sky in Turner's picture and I mention it again here because skies are so important. Cotman's skies were always beautifully thought out, and the slabs of grey and blue well placed to complement the composition. He never managed a wet loose wash in the sky like Turner did; that was not Cotman's technique, he was mainly a dry-brush man. I think most of his pictures were painted in the studio from drawings or coloured sketches done on the spot. This picture was

undoubtedly a studio work.

The river is left the natural colour of the paper with only a light grey wash over it in the foreground, which continues a cloud shadow that is over the sloping ground near the town. There are some light blue distant washes over the river in the distance.

I suppose one could say Cotman's favourite colour was a yellow-brown as he uses Yellow Ochre and Sepia or Burnt Umber a great deal to pleasing effect.

Note the very dark mountain in the middle distance caused by a heavy cloud shadow. I am always telling my painter friends about the importance of cloud shadows in landscape. It is the main item which brings things to life and is much more pleasing than a landscape on a clear blue-sky day when there are no dark accents to show up the gleaming sunny patches. Cotman was a master of this treatment, as were so many other of his contemporaries.

He was also a master of drawing and painting buildings, old houses, churches and castles.

We can learn so much from Cotman's brilliant draughtsmanship; his drawing was never at fault, and so with his colour sense a beautiful painting naturally resulted.

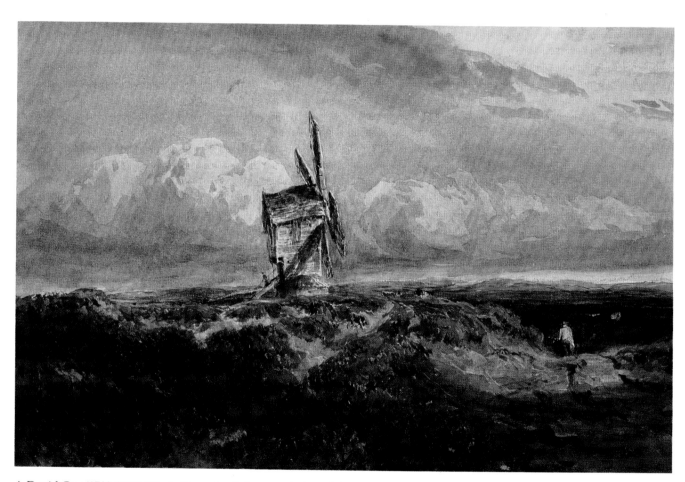

4 David Cox (1783-1851) *Windmill on a heath* (by permission of the British Museum, London) 180 x 255 mm (7 x 10 in)

David Cox (1783-1851)

Windmill on a heath
David Cox was a real countryman if ever there was one and he loved best the open moor such as he found in north Yorkshire, or wild mountain scenes in his beloved Wales. He is renowned for his landscapes with a strong cross-wind blowing and a figure or two leaning against the wind with garments blowing out sideways.

The picture I have chosen with an old post mill on an open heath is typical of his work. Here we have a windy sky of blustering clouds and a lovely composition. Note the position of the mill a little left of centre and the track to the right with the figure on a pony which is in such a perfect position, drawing the eye away from the mill and into the distant moorland. The middle distant

country is in dark cloud shadow, probably a mixture of Sepia and Ultramarine, and the far distant rising ground is in brilliant sunlight, just a narrow streak and so effective. The colour would be Yellow Ochre and probably painted early on in the picture.

The light coat the figure is wearing was probably lifted out with a stiff wet brush and then blotted. Cox used this technique quite often and he also applied thick body-colour to a figure or horse as occasion demanded. He used scratching out with a knife in many cases, for instance when highlighting a dog against a dark background or indicating birds.

The track is beautifully painted with cart-wheel marks using his technique of short brush strokes, and the vegetation on the heath also has the small brush stroke method. His early paintings had the big flat wash treatment, but later he gradually adopted the short brush stroke dabs of colour which suited his desire to convey movement and atmosphere. I find this painting style of his very effective.

Turner used to call him Farmer Cox as he was so fond of wild country subjects with farm carts and rustic figures. He made a great study of these things in sketch books filled with pencil drawings and notes.

Apparently he discovered one day that some light brown rough packing paper was good to draw and paint on and thereafter he adopted a toned paper for much of his work. Early in the twentieth century a British firm started to make what they called David Cox paper; it was an oatmeal colour with a rough texture and absorbent quality, most suitable for watercolour work. This paper was very popular with a great many artists including myself, but about 20 or so years ago the firm stopped making it, which was a sad loss to the painting community.

Cox used clear transparent washes combined with quick thick applications of paint. The foreground cloud shadow over the track is transparent and the wheel tracks are painted with thick brown paint, as is some of the foreground heather growth. The mill itself is beautifully portrayed with very little pencil drawing and mostly drawn in with a small brush in a rough quick style. Note the figure coming down the mill steps with a red cap on. This nice touch of bright colour is typical of Cox, and he often had a red shawl draped on an old man or woman to very telling effect. Bonington, born a few years later, was also very fond of the splash of red to give a sparkle to his pictures.

Cox could paint building subjects beautifully and there are many lovely street scenes to be seen of his work in London and other picture galleries. He did a lot of teaching and wrote books on watercolour technique, in order to help other artists. He was known to be a very generous and kindly man who gave up much valuable time that could have been spent creating landscape masterpieces.

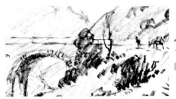

5 Peter De Wint (1784-1849) *The Valley of the Thames and Cliveden Woods* (by permission of the Fitzwilliam Museum, Cambridge)
300 x 467 mm (11 x 18¾ in)

Peter De Wint (1784-1849)

The Valley of the Thames and Cliveden Woods

If David Cox was a countryman who loved wild open windy subjects, De Wint was a countryman of another type: his favourite subjects were in summer at harvest time when men and women were in the cornfields gathering in the crops by hand, and horses and farm wagons were in evidence. He was born in Staffordshire, the son of a doctor. He met Girtin when he moved to London as a young man and was strongly influenced by him; Girtin had a lasting effect on his work. He lived for much of his life in Lincolnshire and a lot of his landscapes are of the surrounding countryside, with often a distant view of Lincoln cathedral included.

The picture we have here of Cliveden woods and the distant view of the River Thames is a most stunning piece of landscape painting. I feel sure it was painted on the spot as there is that spontaneous brushwork as if he was working against time to catch the late afternoon warm glow of sun on the banks of the country lane, and a lovely pink and light blue sky applied in wet washes. He also made an oil painting of this subject, probably a studio work taken from the watercolour. The oil is good but not quite so masterly as the watercolour. I examined the watercolour closely at the Fitzwilliam Museum and it is on a slightly tinted wove paper. The four white pigeons seen against the dark wood were cut out with a sharp knife; I looked at these with a magnifying glass and they were most skilfully done and as fresh as if they had been scraped yesterday.

De Wint was not as a rule a man for cloudy skies, and he often painted on an ivory-tinted Creswick paper and was quite content to leave the sky untouched. This seemed to suit his colouring so well and was most effective.

An artist friend of mine who visited a De Wint exhibition some years ago came away with a list of ten colours used by him – Indian Red, Vermillion, Purple Lake, Yellow Ochre, Gamboge, Brown Pink, Burnt Sienna, Sepia, Prussian Blue and Indigo. But here again my friend Walter Shaw Sparrow gives a longer list of 17 colours. The extra ones are Brown Madder, Pink Madder, Orange Ochre, Vandyke Brown, Olive Green, Cobalt Blue and Emerald Green.

It is always interesting to discover the range of colours these great watercolour painters used. Referring again to our illustration, I think De Wint used a well-diluted Prussian Blue in the sky and Brown Madder mixed with Yellow Ochre for the clouds. The very far distance was probably a mixture of Brown Madder and Prussian Blue. The less distant woods on the left look to me like Cobalt and a touch of Yellow Ochre – they are a very *blue* green.

The central dark woods are a gorgeous rich deep brown-green colour, probably a mixture of Sepia and Prussian Blue. The blue has, I think, faded out of the painting a little, as the predominating tone is definitely brown. (Prussian Blue has always been a notorious colour for fading after a long period of years.) The even darker trees on the right foreground are, I think, the same two colours with a touch of Brown Madder added. The lighter washes of the lane and earthy banks may be Orange Ochre and the rather nice green bushes on the left of the lane are probably Yellow Ochre with a touch of Prussian added.

The excessively dark shadow from trees across the lane could be Indigo and Brown Madder fading to a lighter green at the left side by adding some Yellow Ochre. I feel that De Wint was in a hurry to get these dark shadows in and mixed his colour a little bit too dark in the rush. But their strength is very effective in giving the feeling of strong sunlight on this rough track.

Most of the washes are applied fairly wet and this is the dry-into-wet technique with direct application of brushwork. I like the quick touches in dark brown on the left foreground with a small brush, giving a little textured detail.

This picture shows the pure watercolour tradition of getting the tone values and colours painted *right* first time and then applying final touches of overpainting with clean dark brush strokes.

De Wint's landscapes have been called psalms in watercolour: they are sheer poetical works that carry one into a dreamland that is perpetual summertime in old England.

We have now finished our brief examination of each of five great watercolour landscape painters, and I have managed to pull out some useful points about each one that should give us some food for thought when it comes to making our own watercolours. Points like good basic drawing or knowledge of drawing, sound composition, deciding on tones and colours to use and the vision to enable us to find a suitable subject are invaluable.

Talking about 'subject' brings me to the all-important fact that the countryside in Britain and abroad has changed enormously since these men were painting in the 1800s and 1850s. They had hundreds of square miles of unspoilt country offering roads for slow-moving horse traffic; farmland with proper hedges and ditches and hedgerow trees; woods and rivers with interesting sailing craft; wonderful groups of farm buildings, and of course villages and towns whose buildings up to the end of the nineteenth century were dreams of artistic architecture. The only handicap those painters had was transport. They had to get about by walking for miles with their sketching kit, or travelling by pony or cart, or coach if they could afford it. But they were tough individuals and determined to explore and discover. Men like Turner would spend many weeks travelling across Europe to Venice and Rome.

We modern painters have the advantage of travelling in a comfortable car and good roads to take us to lovely places like the Lake District and Scotland and all over Europe, as well as further afield. But of course the countryside has been cut up badly with the big motorways and town expansions, and it is therefore not as easy as it was to find a good subject. Having said that, I hasten to add that there is definitely a great deal of beautiful unspoilt countryside still remaining – it just takes a little more finding than it did even since my own early days of painting in the late 1930s – and there are still really wild places which are nature in the raw in many areas of Wales and Scotland, the Lake District, the Yorkshire Moors and remote parts of North Norfolk and the West Country. The area where I live – Gloucestershire – has been tidied up a good deal, which we artists don't like, and this applies to many other counties as well; but it is still possible to discover an untidy corner deep in the country where the hedges have been allowed to overgrow and there are old ivy-clad trees and dirty old ponds and very occasionally an attractive collection of ancient stone farm buildings, barns and lean-to sheds with stone roofs, all of which give the artist good subject matter.

This book is about painting rural landscapes mainly in Britain, but also in Normandy, Venice and Florence, etc.; though the techniques and advice could, of course, be applied to landscapes worldwide. I am not suggesting we should slavishly copy the old master painters but we can absorb a lot of their enthusiasm and the way they set about finding a subject and painting it. Sometimes they worked on the spot but a lot of the time, owing to the difficulties of travel, they made pencil

sketches in the more remote regions with notes about colour and light and atmosphere and then made beautiful paintings in the studio from the pencil sketches when they reached home. We can do this today but I advocate plenty of painting on the spot as well, so that we may learn all about nature's moods and acquire knowledge of how to paint shadows, cloudy skies, rocky foregrounds, distant woods and mountains and all the thousand and one items that make up a landscape.

One final word about the old master painters. In the early days they had to grind the colours to powder before they were usable as watercolour. Then in 1780 William Reeve invented a soluble hard-cake which, when used with the addition of water, could have a binding medium, such as gum arabic, added and then the colour could be used in thin wet washes as desired. Later in 1832 Winsor and Newton developed a 'moist' colour in tube or pan and this enormously encouraged artists to paint out of doors with their paints ready for immediate use.

So we are very lucky today to have lovely moist watercolours made by many paint firms; but when it comes to paper, life is not so easy. There are a number of makes available but none I think is as good as the beautiful wove papers these early men had to use. I shall say more about this in the next chapter.

2 Understanding and choosing materials

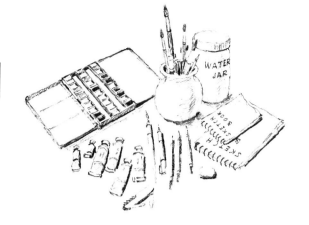

In this chapter I give you a list of various materials that I use myself – pencils, pens, brushes, actual colours etc. – and which I have found suit my way of painting over the years. I suggest you obtain the same items yourself so that you can follow more easily the ideas and techniques I hope to impart to you and then make your own practical applications actually on paper.

What I do not want you to do is to feel you must always paint my way; I would much prefer that you develop your *own* ideas and style of painting and simply use my ideas as a guide to start with.

I also give here a list of possible colour mixes which you may find helpful in carrying out some of my ideas. But as you progress you will undoubtedly discover mixes of your own which you prefer to use.

Pencils, pens etc.

Pencils

There is a wide range available, as I am sure you all know, starting with various grades of the hard H pencil, which I never use, and going on to F, which is a useful one to have occasionally when drawing on very rough paper. I like to keep a stock of HB, B and all the way up to 6B. I usually use a 2B or 3B for initial sketching in on say a Bockingford paper before carrying out a watercolour. But for a ROUGH paper I would use a B or even an HB pencil. For making

a pencil drawing on cartridge paper, not to be painted or only to receive a light wash, I will use a 4B, 5B or 6B very happily, as you need the soft pencil to put in really dark accents or for broad shading.

Therefore my advice is to have a good stock of all grades of pencil. You never know when the weather is going to turn wet and you have to make a quick pencil sketch instead of a painting, sheltering under a tree or your painter's umbrella. This is better than doing no sketch at all and you can paint a picture from your pencil sketch when you get home.

A stick or two of Conté crayon is very useful when broken into short lengths 1 cm (½ in) long; it can be used sideways on cartridge paper to fill in shaded areas to great effect. You can get different grades – B, 2B, 3B etc.

Pens

A 'relief' nib in an ordinary pen holder is useful, while an old fountain pen often has a good nib for carrying out ink drawing combined with watercolour washes.

For *felt pens* I like the Staedtler 'M' for medium or 'F' for fine. They are permanent, i.e. do not fade (most important), and waterproof so that when watercolour is applied the ink does not run (also very important). There are various other makes, but be careful how you choose them.

Rubber

You should not require this often, but an excellent make is Berol Venus Soft Eraser.

Paints

Now we come to the most important item. I limit myself to 12 colours and for many pictures I use only about eight. You do *not* require a lot of colours. With *few* colours you can get to know what to mix together so well that you hardly have to think about it and you can produce the right shade of colour and get on with the picture quickly. One is usually in a hurry with watercolours when painting out of doors, trying to catch the light before it changes. My list is as follows:

1. Cadmium Lemon
2. Cadmium Yellow
3. Raw Sienna
4. Burnt Sienna
5. Burnt Umber
6. Light Red
7. Indian Red
8. Rose Madder
9. Cobalt Blue
10. French Ultramarine
11. Winsor Blue
12. Payne's Grey

After many years of experience I find these colours will give an extremely good variety of shades when the right ones are mixed together. They are also chosen for what the manufacturers call 'permanence', that is to say they

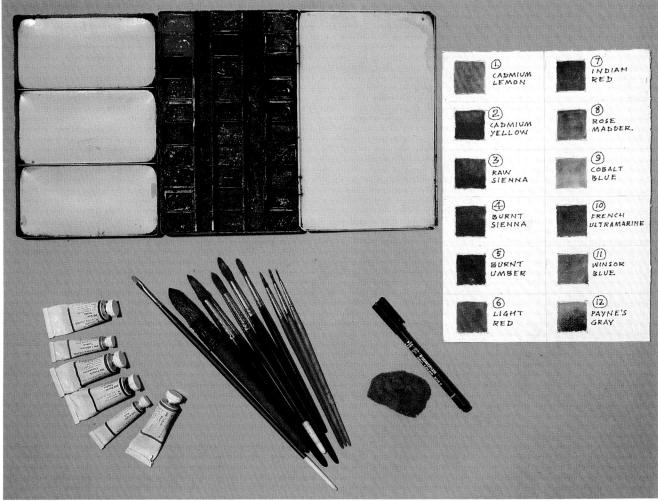

6 Painting materials

do not fade with age. Some colours like Chrome Yellow are called 'fugitive', which means they *do* fade, so it is better not to use such colours. All the ones in my list are permanent colours. (Watercolour pictures should never be hung on a south-facing wall near a window and certainly never where they could get direct sunlight on them. They will definitely loose colour and fade if this is done.)

Paint box

I use a large paint box measuring 216 x 140 mm (8½ x 5½ in). This is ideal, as when opened up it has two mixing palettes, each of course measuring 216 x 140 mm. One palette is flat, the other divided into three recessed dishes. It was bought from a lovely art shop in Jermyn Street, London, called Lechertier Barbe, who were the actual makers; the box is about 50 years old. The shop has, sadly, long since closed. I mention this because the sad fact is that you can no longer buy a box like this and the best you can get from Winsor & Newton or Rowney is a box 216 x 76 mm (8½ x 3 in) which gives rather small mixing palettes. I have spoken to both these firms often, begging them to make larger boxes, but I am afraid they do not listen to me. Perhaps some of my readers can persuade them!

However, you need not despair for there is a box on the market called Liz Deakin Watercolour Palette, measuring 241 x 203 mm (9½ x 8 in) when open and 241 x 102 mm (9½ x 4 in) closed. It has seven mixing wells and 15 small recesses to take colours squeezed from tubes. It is made of white plastic, not as nice as metal, but it does work and I have one as a spare. It should be available in art shops, but if in difficulty the main stockists are Frank Herring & Sons, High West Street, Dorchester, Dorset.

Paint makers supply large and small pans of colour ready for immediate use filled with 'moist colour'. I use the large pan in my box and as it gets empty I replenish it from a tube. Actually my pans were emptied years ago and I always use colour from a tube and am constantly filling up the pans. It is *most important* to have your colour *soft* so you do not have to damage your brushes when trying to soften up a colour

which has gone hard. One trick I use is to soften up the colours by working at them, before going painting, with a stiff oil painter's brush dipped in very hot water. It is worth doing this if there is the least chance of your colours being hard in the pans, having not been used for a week or two.

At this point you might like to refer to Figure 6, which shows my paint box and a colour chart beside it. If you count the pans in the box you will find there are more than 12 because for some colours I have two pans full of the same colour, namely Raw Sienna, Burnt Sienna, Burnt Umber, Cobalt Blue and French Ultramarine. I find I use extra quantities of these colours.

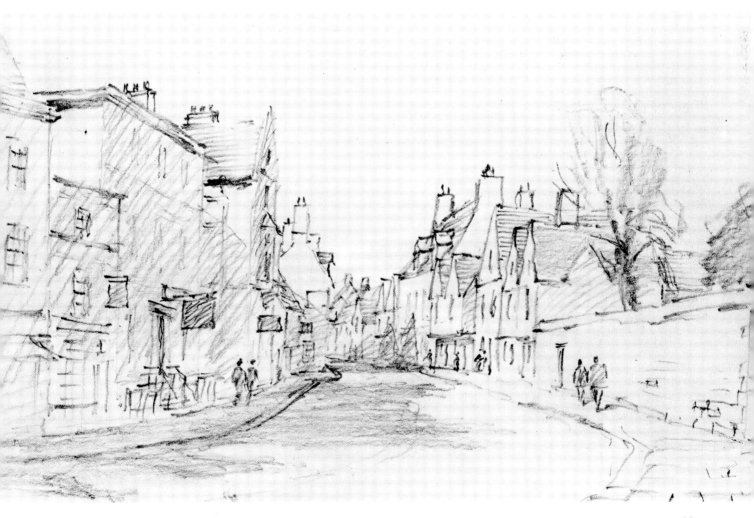

Brushes

I have used sable brushes for many years, but they have started to get very expensive and so I have tried out the much less costly synthetic brushes made by all the well-known firms. These are quite good but not good enough to exclude the use of the sable, which holds water better for big washes and generally performs better for tricky jobs like painting trees and mountains where you want to get a rough edge to a wash. I still, therefore, pay out the high price for an occasional sable.

In Figure 6 the brushes shown are, from left to right:

1. A No. 1 oil painter's bristle brush for lifting colour and generally scrubbing out.
2. Large squirrel hair brush for wetting the paper, sky washes, trees and any big wash.
3. Sable brush No. 16, a very old one costing about £8 years ago.

Has worn down to about a No. 12. Invaluable brush for fairly large washes. The cost of a No. 16 Sable today would be well over £100.
4. Synthetic No. 10 brush. Quite good. About £2.
5. Sable No. 8, costing about £25. Very useful size for many areas of a landscape picture. You could almost paint the whole picture with it as it retains an excellent point.
6. Sable No. 5.
7. Sable No. 4. Old brush.
8. Sable No. 3. Old brush.
9. Sable No. 1. Old brush. Useful for winter tree branches.

The last three I have had for a good many years and they are still giving excellent service. These nine brushes are ample for my needs for most pictures. I do have a lot more old ones but you can manage with Nos. 1, 4, 8 and 12 quite adequately and the large one need not be a sable. I would recommend these four brushes to any beginner.

Brushes are really even more important than the colours, as you can paint a reasonable picture on poor paper and with poor colours but *not* with poor quality brushes.

Also in Figure 6, I show a small sponge which art shops supply and which is useful for wiping out areas of painting. It is also useful to clean up your paint box after a day's painting. Do always have clean palettes before starting to paint; you will mix much cleaner colours this way.

Also in the illustration is a felt pen by Staedtler, No. 303; and to the left are four large tubes of watercolour paint and two small tubes.

Paper

Watercolour paper is very much a matter of personal choice depending on your style of painting. It is made with different surface finishes:

1. HOT PRESSED which is very smooth like a cartridge paper. Good for drawing on but not favoured by most people for painting.

2. NOT – this surface is textured but not too rough and I usually use it myself.

3. ROUGH which has a good tooth; heavy washes of certain paint mixtures such as Ultramarine and Burnt Umber will separate and give an interesting mottled effect.

Bockingford paper is white and is good for all round use whether for drawing in detail and laying on light washes or for full-blooded watercolour work. I use it a lot and find one can obtain bright luminous watercolours with it. It is made in different thicknesses which, when ordering, are described in pounds weight; the thickest is 250 lb, which I prefer to use as you do not have to stretch it before use (i.e. damp the paper, stick it on a board round the edges and it will dry out smooth and tight like a drum). This is a bother if you are going away to stay and want a lot of sheets ready to paint on each day.

Bockingford is also made in lighter weights at less cost.

Saunders paper is similar to Bockingford, is slightly cream but a little more absorbent.

Arches is an excellent French-made paper and easy to obtain. It is more expensive than most. It has a NOT or ROUGH surface, whichever is preferred. It is a cream colour and made in various thicknesses up to 400 lb. I use the 300 lb quite a lot.

Whatman is a great name in watercolour painting and, as I said in Chapter 1, dates back to 1780. They ceased to make it in about 1960 but, happily, it is now on the market again in sheets of up to 200 lb weight. I am waiting for it to be made in a heavier weight before I use it much.

Barcham Green make an excellent paper called Green's Pasteless Board which is 300 lb weight. Lovely effects can be obtained on it, but it is rather expensive.

Two Rivers is about 200 lb weight and made in three colours – white, grey and buff. It is slightly wavy and really needs stretching, but it is good to use.

De Wint paper is a biscuit colour, about 200 lb and also a bit wavy and not quite flat. Quite nice to use and effective when watercolour is combined with penwork.

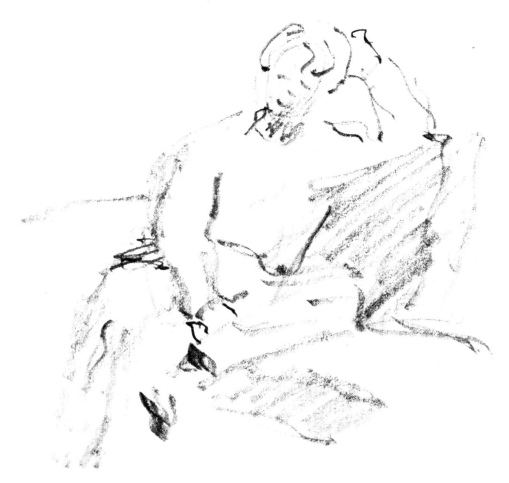

Sketch books

Many are available in watercolour and cartridge paper. I always have a stock of the latter handy for pencil sketching work, from quite small – 105 x 148 mm (4 x 6 in) which is A6 size – up to A3 (297 x 420 mm [11½ x 16½ in]); but I mostly use an A4 and A5.

The Langton sketch book is worth considering. It is spiral-bound with a hardback and consists of 12 sheets of Bockingford paper 140 lb. It is a very good book for a beginner to use; size can be 406 x 508 mm (16 x 20 in), and smaller sizes also.

Before I leave paper I would mention sizes. Nearly all watercolour papers are made to Imperial size which is 560 x 762 mm (22 x 30 in). It is a good idea to standardise the size of painting you are going to make for economy reasons. I usually paint to about 318 x 470 mm (12½ x 18½ in) which is a little smaller than a half Imperial sheet, i.e. 381 x 560 mm (15 x 22 in). I also do a smaller picture to fit in with a quarter Imperial sheet. In this way you utilise the standard sheets that are for sale without any wastage.

Other painting items

Easel

Something that will adjust to a sitting position as well as standing. Also must adjust to horizontal board position for some passages of a painting. Legs to adjust individually in length for uneven ground.

Stool or chair

I prefer a low chair with a back. I like to reach the ground easily where I have my paint box on an old towel on an old rug to level up uneven ground. I sometimes stand up to an easel but more often sit down with the board on my knees. This is purely a matter of personal preference.

Penknife

This comes high on the list for sharpening pencils *and* for scraping out tree branches on a dark background and grasses in foreground etc.

Water

A fairly large jar with a screw top.

Blotting Paper

Comes in useful on innumerable occasions.

Brush case

A roll up fabric case or plastic tube case. Essential to protect these valuable items.

Carrying bag

Have a strap that can go over your shoulder for carrying long distances. This is for holding paint box, water jar, brushes, pencils, towel etc. Paper and board (cardboard will do) are carried separately, as are the chair and easel.

I shall, of course, be saying how to use some of the above items in the following chapters.

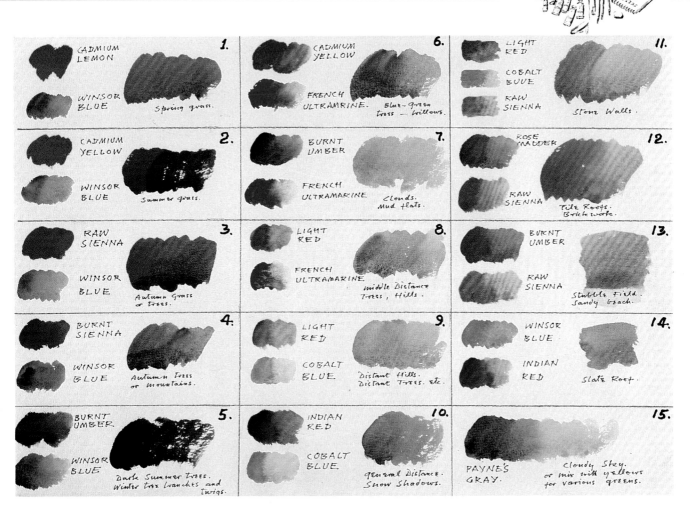

1. CADMIUM LEMON / WINSOR BLUE — *Spring grass.*	**6.** CADMIUM YELLOW / FRENCH ULTRAMARINE. — *Blue-green trees — Willows.*	**11.** LIGHT RED / COBALT BLUE / RAW SIENNA — *Stone Walls.*
2. CADMIUM YELLOW / WINSOR BLUE — *Summer grass.*	**7.** BURNT UMBER / FRENCH ULTRAMARINE — *Clouds. Mud flats.*	**12.** ROSE MADDER / RAW SIENNA — *Tile Roofs. Brick work.*
3. RAW SIENNA / WINSOR BLUE — *Autumn Grass or trees.*	**8.** LIGHT RED / FRENCH ULTRAMARINE — *middle Distance Trees, Hills.*	**13.** BURNT UMBER / RAW SIENNA — *Stubble Field. Sandy beach.*
4. BURNT SIENNA / WINSOR BLUE — *Autumn Trees or mountains.*	**9.** LIGHT RED / COBALT BLUE — *Distant Hills. Distant Trees. etc.*	**14.** WINSOR BLUE / INDIAN RED — *Slate Roof.*
5. BURNT UMBER / WINSOR BLUE — *Dark Summer trees. Winter tree branches and twigs.*	**10.** INDIAN RED / COBALT BLUE — *general Distance. Snow Shadows.*	**15.** PAYNE'S GRAY — *Cloudy Sky. or mix with yellows for various greens.*

7 Colour mixing

Colour mixing

Figure 7 really explains itself, but I will briefly run through the 15 colours produced by mixing two colours together and give you some ideas about their uses. I would like you to familiarise yourself with these mixes by trying them out on a sheet of white paper; you will then be able to produce the subtle colours you see when painting a landscape on the spot.

Painting out of doors is usually a race against time, and colour mixing is an *essential* knowledge which you must have in order to be a good painter.

1. *Springtime greens*
Cadmium Lemon and Winsor Blue mixed together will give a variety of very bright greens so useful for springtime tree and grass colours, especially when in bright sunlight.

2. *Summer greens*
In mid and late summer the grass is darker and so is most tree foliage. Cadmium Yellow is a very lovely orange-yellow, a strong pigment which produces a beautiful rich green when mixed with Winsor Blue.

3. *Autumn grass and trees*
Raw Sienna is the ideal yellow to use with Winsor Blue to give a good autumn grass colour which is often almost pure Raw Sienna in colour. Use this mix for autumn tree foliage also.

4. *Autumn trees and mountains*
Burnt Sienna, that most beautiful and useful colour, can be so good for a Scottish mountain with a touch of Winsor Blue added. This mixture is good for autumn trees also. Burnt Sienna can be just right for pantile roofs in Norfolk, flat-tile roofs in Sussex or old village roofs in Italy,

France and Spain. Add a little Raw Sienna to lighten it or Burnt Umber to darken it.

5. *Winter trees*
Burnt Umber, another very fine colour with *many* uses, is excellent when mixed with Winsor Blue for winter tree branches and twigs. But this mixture can also be lovely for very dark late summer tree foliage.

(You will notice I have used Winsor Blue five times running in these mixes which shows what a valuable colour it is. The old masters, of course, used Prussian Blue which was a notorious colour for fading with age. Winsor & Newton produced Winsor Blue comparatively recently to be a substitute for Prussian that would be permanent.)

23

6. *Blue-green*
Willow trees and sometimes chestnuts in full summer are a bluish-green, and Cadmium Yellow with French Ultramarine produce a good blue-green colour.

7. *Grey skies*
Burnt Umber and French Ultramarine give an excellent grey for cloudy skies. When using a good quality handmade paper, this mixture separates nicely and the granulations of colour give a pleasing texture. This same mixture is also good for mud flats in an estuary.

8. *Middle distance*
Mix Light Red with Utramarine for a good warm grey for middle distant blocks of trees and woods or hills.

9. *Distance*
For distant trees or mountains or any distant objects a mixture of Light Red and Cobalt Blue is excellent.

10. *Snow shadows*
Indian Red and Cobalt give a nice purplish grey which is useful for shadows on snow or far away hills. Indian Red and Ultramarine is the same but intensified.

11. *Stone walls*
Sometimes one has to mix three colours together, as, for example, getting a warm stone-wall colour such as is required in the Cotswolds or for a Scottish castle. Light Red and Cobalt gives the cool grey and then Raw Sienna is added to warm it up.

12. *Brick walls*
Raw Sienna with a little Rose Madder is good for brick walls of houses and also for tile roofs. The mixture can be varied considerably.

13. *Sandy beaches*
Raw Sienna and Burnt Umber, but mostly the latter, can be just right for a beach scene, and equally good for a stubble field at harvest time.

14. *Slate roofs*
Winsor Blue and Indian Red is excellent for those Cumbrian stone farmhouse roofs. A very useful slate grey.

15. *Grey skies again*
Payne's Grey, when used all on its own with no mixing with another colour, can be awfully good for a rather blue-grey sky which we sometimes have in Britain (the Payne's Grey for this particular mix should be Winsor & Newton's).

Payne's Grey is useful to mix with Burnt Umber for the dark tone seen in windows and open barn doors etc. Also, when mixed with various yellows an attractive mellow green is produced. If mixed with Raw Sienna a very good pond green is produced and I have found this is often right for the water of a Venice canal, for instance.

I said at the beginning of this section on colour mixing that I hoped you would practise these mixes yourself on some white sheets of paper. You can do more than this if you like and invent mixes of your own, using the 12 colours I have suggested; you will learn a great deal about watercolour painting if you do.

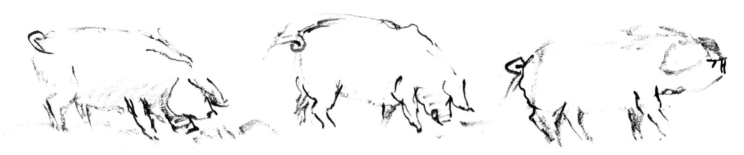

3 How to choose a subject

The more we paint and draw landscapes when we are *out in the open countryside*, the better and quicker we learn how to choose a *subject*. I nearly always have a small cartridge sketchbook in my pocket when out for a walk with the dog or by myself. I sometimes jot down, for example, just a single willow tree on the Windrush river bank, nothing more. That could make a small picture on its own with a sapling and a tuft of grass added. We don't always have to find a view with a whole lot of incidents – a wood, a cottage, a hill, a foreground dead branch, a sky. A single tree may be called a 'study', but in the hands of an accomplished painter it can be a delightful picture; it all depends on *how* it is painted. If it has that fresh quick colour application look with no unnecessary fuss, it can be a winner! This is why I am asking you to get into the habit of making pencil sketches of small subjects. Your eye will gradually be trained to spot a subject consisting of almost nothing. It could be just a mud-flat in Norfolk with a lovely sky – nothing else. But the key to the success of such a simple subject is the *way in which the watercolour has been swept cleanly onto the virgin paper*. Look at a blank sheet of paper with a lovely NOT surface texture and then see in your mind's eye some brush strokes appearing, strongly, boldly applied, and you will begin to know what a good watercolour means. What I am describing

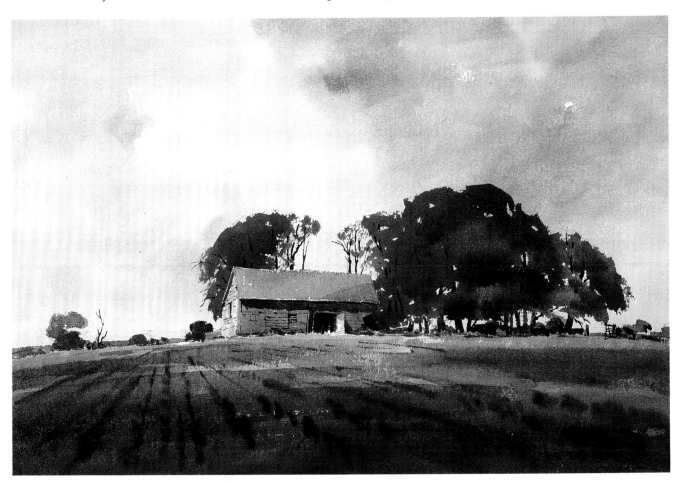

8 *Barn above Bower Chalke, Wiltshire* 317 x 476 mm (12½ x 18¾ in)

now is perhaps the most important part of this whole book – *the application of wet washes of colour*.

We have seen in Chapter 1 a little of how the master painters worked, and one must understand from the beginning that for watercolour painting one must be *two* things: first an *artist* and second a *craftsman*. One cannot have one without the other. The *artist* has the vision and eye to see a subject; he can feel the atmosphere and be inspired by nature's magnificence and poetical charm and long to put it all down on paper. But if he does not know how to paint it onto the paper he will make mistakes – perspective all wrong, tone values all wrong, brushwork untrained and amateurish – and it will be a failure. So he must have *craftsmanship* also, i.e. the technique of handling watercolour. This sometimes comes as a difficult medium to those who have handled only oil paint and to beginners who have no system and method of working. So we have to be *craftsmen* as well, and in this book I am trying to help you to be both.

One of the secrets of choosing a subject is not to choose something too difficult. Choose one you feel almost sure you can paint; imagine it already on the paper and think just how you are going to handle it.

Let us look at Figure 8. Here we have an extremely simple subject – a barn and a small copse, sky and a ploughed field – painted at the end of September. The trees were dark but not yet turning yellow and brown.

You are inspired by the simple dignity of the well-proportioned barn, with its large dark opening, and you start to visualise this on your sheet of paper long before you start to draw or paint. What is the first thing you think about? It is where the barn and tree group is to be placed on the

9 *Barn above Bower Chalke*, Sketch 1 152 x 203 mm (6 x 8 in)

10 Sketch 2

paper; this is called getting the *composition* right. Choosing a subject is very much tied up with composition, which virtually means the placing of objects in the picture.

Let us look at the charcoal sketch, Figure 9. Here we can see how it would look to have the barn and trees to the left. This is obviously not a happy composition. Now look at the

second sketch, Figure 10, with the barn to the extreme right and the trees running out of the picture. This is unbalanced with too wide a blank space to the left. So we settle for having barn and trees a little bit off-centre to the right, as shown in Figure 8. Your eye tells you this is correct. The left-hand gable-end of the barn catching the sunlight is, so to speak, looking to the left-hand

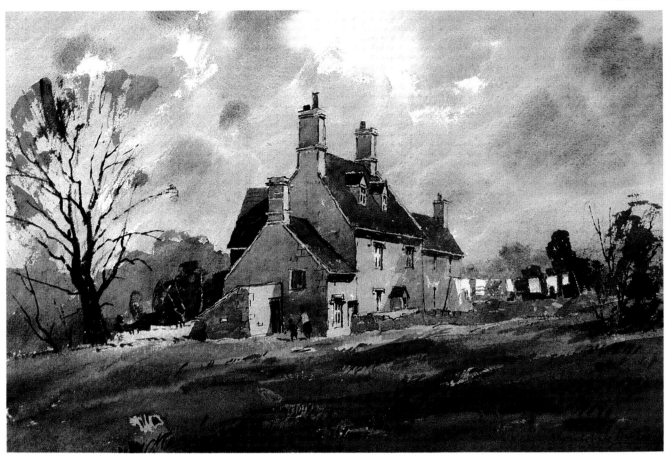

11 *Stone Cottages at Windrush, Glos.* 317 x 476 mm (12½ x 18¾ in)

side and you do require a bit of space to the left rather than to the right side of the group.

The horizon is one-third up the paper leaving two-thirds for sky – often a nice proportion to work to. Note how the plough marks in the foreground soil converge to a vanishing point and help greatly in giving perspective and distance.

Anyone could attempt this simple subject, beginner or mature painter. The colours used were Payne's Grey and Raw

Sienna in the sky with a touch of Ultramarine in two places, keeping everything wet as it was painted. The foreground earth was Burnt Umber with some Ultramarine added. The barn's dark wall was the same as the earth with rather more blue in the mixture, and the roof was Winsor Blue and Indian Red. Trees were various mixtures of Raw Sienna, Burnt Sienna and Winsor Blue. The thin line of distant hill and small tree on the left was Light Red and

Ultramarine. Eight colours were used in all.

Another type of subject is a village cottage, and if you look at Figure 11 you will see an example of this. There is a little more drawing required here than in the barn picture but it is still quite a simple subject. It was painted at the end of April with trees still bare of foliage. The washing on the line gave a small item of interest and the two figures indicate that the place is inhabited.

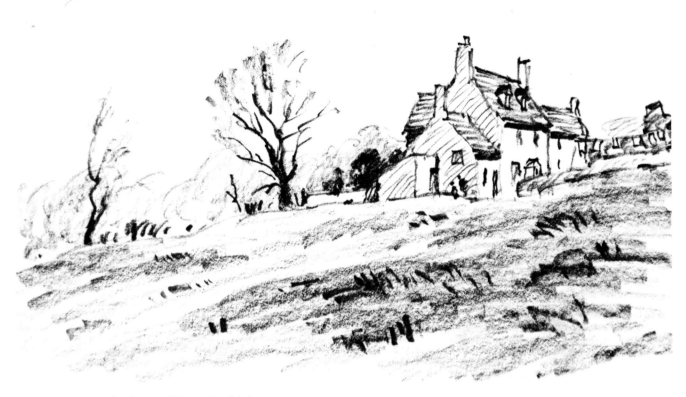

12 *Cottages at Windrush* 152 x 203 mm (6 x 8 in)

Now look at the charcoal sketch, Figure 12, and we can see how the composition might have been arranged; it is clear that the cottage group (there are two cottages actually) is much too far to the right and the tree interest to the left is not a sufficient counter-balance.

When composing a picture and looking at my blank piece of paper I often sketch in the subject with my forefinger, using it like a pencil but making no mark on the paper. This is a useful trick and saves you having to make a rough small sketch in pencil first. Having drawn with your finger you can tell roughly how big to make things and if they are in the right position.

I am not going to describe in detail how this picture was painted, what colours were used and how they were washed on, as these details are given in full for various types of painting later on in the book. I will just mention that I used a certain amount of penwork with this watercolour. In this chapter we are only concerned with how to find a subject.

If you are having difficulty finding a subject you can always choose a country road. Try to find a place where the road bends out of sight and where there is perhaps a gate in the hedge.

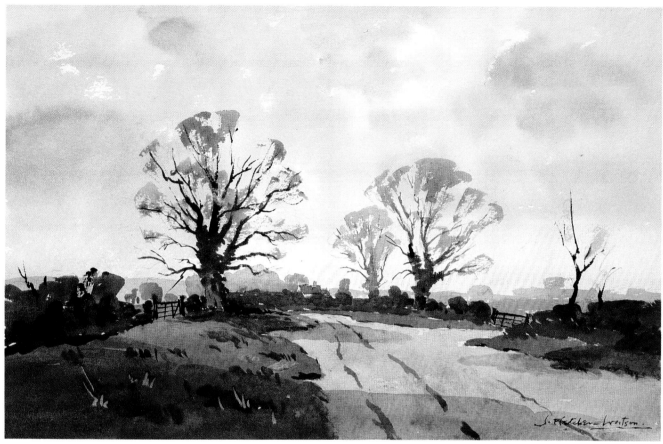

13 *Country road, Glos.* 317 x 476 mm (12½ x 18¾ in)

Watch out for interesting trees with twisting old trunks and an artistic branch pattern. Figure 13 shows a painting of a Cotswold road in winter, and various tree trunks are covered with ivy which I always like to see and paint. Also note carefully which point the sun is shining from and whether the shadows falling across the road will be interesting. All these things are part of composition. If you are an experienced painter you can invent the shadows if it is a dull day and you want to have a gleam of sun.

Another easy subject is a small barn. We have already had a large barn in Figure 8, but there are a great many small barns scattered throughout Britain especially in counties like Yorkshire, Lancashire and Gloucestershire. Figure 14 shows a nice stubble field in the Cotswolds painted in August:

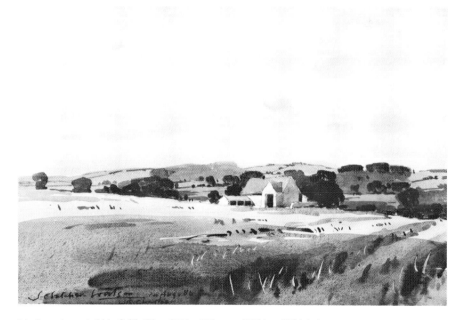

14 *Barn in a stubble field, Glos.* 317 x 476 mm (12½ x 18¾ in)

warm yellow-brown colours in the foreground and cool green-greys in the background. The barn itself is a warm grey stone colour and is carefully placed to the right of centre. The dark tree groups give strength and balance to the composition. But what a simple and pleasing subject this is. It took about one hour to paint.

29

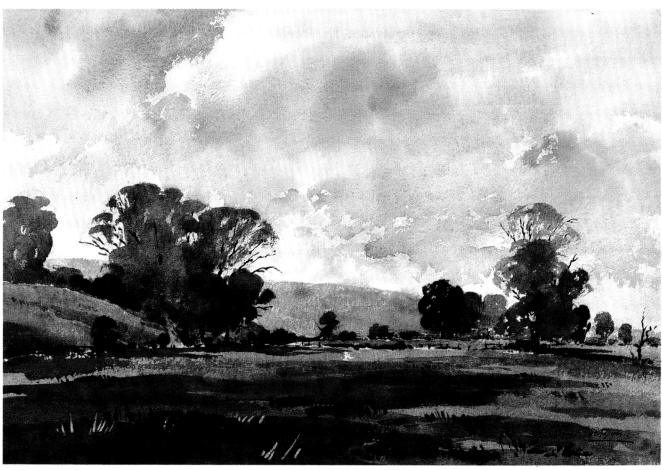

15 *A Wiltshire field* 317 x 476 mm (12½ x 18¾ in)

A subject is so often found because of the interesting light, and my next painting, shown in Figure 15, is just such an example. All we have is trees, grass and sky with a distant hill. This is a Wiltshire view which I noted as I drove slowly in the car looking for subjects. It was a cloudy autumn day with cloud shadows moving across the landscape leaving thin strips of field lit up with sunlight: a truly Constable-like subject. Some of the trees in dark shadow were darker than others, and I could have fun working out the tone pattern which most appealed to me. So remember to go looking for a subject on a cloudy, windy day with gleams of sunlight and remember also to drive *slowly* in your car so as not to miss some gem of a view to left or right. The police would no doubt deplore this advice as dangerous driving, but as long as you do it only on lonely country roads, it would seem a reasonable enough thing to do!

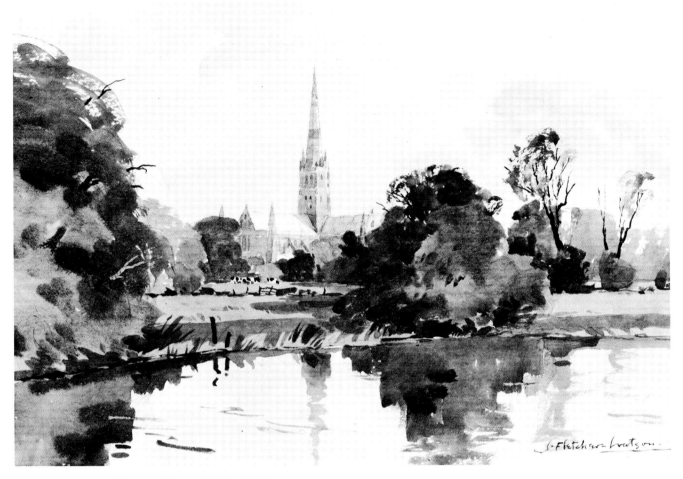

16 *Salisbury Cathedral* 317 x 476 mm (12½ x 18¾ in)

Figure 16 shows a painting of Salisbury Cathedral seen across the river; this is an irresistible subject, and it was necessary to think carefully about the composition before starting to paint. I placed the cathedral left of centre and made my darkest dark on the tree group to the right of it. Everything else was gauged accordingly, painting other trees and the river bank in simple undetailed washes so as not to bring the eye away from the focal point – the cathedral. This was a delightful subject with cattle grazing in the far field and lovely reflections in the water. Note the heights of the various tree groups; none of them is the same height and they form an interesting pattern against the skyline. If I found a tree height was level with another one, I would certainly

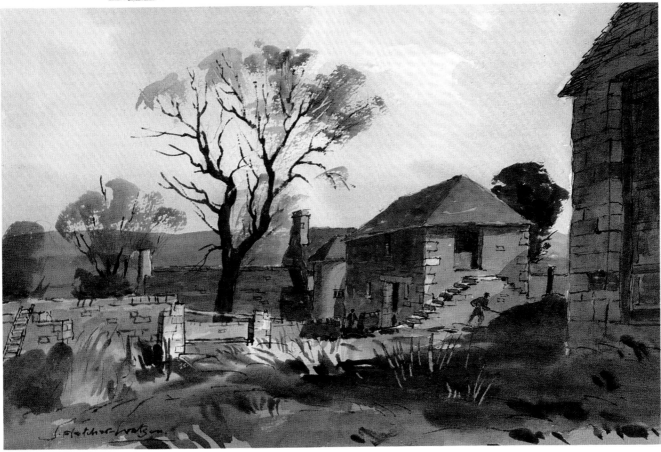

17 *An Oxfordshire farmyard* 317 x 476 mm (12½ x 18¾ in)

alter its height if that was an improvement. Don't forget that we are *making pictures* not *taking photographs*, and artist's licence is a right and proper thing to use.

If you feel like painting a busy farmyard subject, do remember to *half close your eyes* when looking at it so that you can simplify it. I show such a picture in Figure 17. By carefully arranging the many features of barns, roofs and house chimney sticking up against the skyline, the tall tree nearly but not quite in the centre and the dark tree behind the barn to the right, I found I could hold the whole composition together by judicious use of *tone values*. The values are the gradations of dark and light and you can only sort them out by half-closing your

eyes and regarding the different features as just so many shapes. This is what Cotman managed to do to perfection.

I used dark brown pen and ink before applying watercolour; it is a nice technique to use for building subjects and I will tell you more about it in Chapter 11.

The great thing about choosing a subject is to keep an open mind and not have too many preconceived ideas before you set out. And you must keep a wide open eye as well for shapes and colours of, for example, grey distances, or busy tufted grass foregrounds, or for a small area of light catching a wall of a building. Don't be afraid of putting in plenty of dark areas in a picture so as to emphasise the light parts. You cannot get light

without having dark; remember that.

Of course there are plenty of subjects to be found in towns, and I have dealt only with cottages or rural scenes in this chapter. There are many more illustrations in the forthcoming chapters to give you further ideas about subjects. But I hope I have helped you to know *how* to start looking for a subject; it is all a matter of becoming an acute observer not only of 'objects' but of 'nature's moods' which produce light and shade.

Choosing a subject is so much a matter of developing an eye for catching some humble little view that most people would pass by as nothing worth noticing.

4 How to paint skies

I always regard skies as a very important part of any landscape painting because it sets the whole tone of the picture. I recall the immortal words of Constable when he was talking to his old friend Archdeacon Fisher of Salisbury: 'That landscape painter who does not make his skies a very material part of his composition, neglects to avail himself of one of his greatest aids'.

With architectural subjects one sometimes plays down the sky to avoid distracting the eye from a building subject, such as is shown in Figure 88 of houses and the old bridge in Florence. And in some street scenes there is not very much sky showing, as we observe in Figure 77. (Both of these are in Chapter 11.) But in most open landscapes in country areas and mountain regions, the sky is a very important element indeed.

I will start with *how* to paint sunny blue skies, and if we look now at Figure 18 we will see an example of a lovely blue sky with wisps of white cloud. This is a picture of *Horsey Mere*, *Norfolk*, and the blue sky has a pleasing effect, producing blue water reflections.

The method of painting is as follows:

1. A very little pencil work was required, mainly to note the horizon line with a light touch of a 2B pencil.

2. The *whole* picture area, sky and water, was wetted with a

18 *Horsey Mere, Norfolk* 317 x 476 mm (12½ x 18¾ in)

clear wash of water using a fairly large brush. The paper used was Bockingford, but Arches ROUGH would have been just as good.

3. One or two places in the sky were left dry when the water was put on, so that parts of the white clouds would have a sharp edge.

Now pure French Ultramarine was mixed, a fairly generous quantity and a strong mixture. I started at the top of the paper and with a No. 12 brush I ran in the colour in broad sweeps leaving white areas of paper as I came down the sheet. As I progressed down I added water in the mixing dish of my paint box so as to dilute the blue to a lighter colour. The water of the mere was treated in the same way in reverse, i.e. darker at the bottom of the picture. I left the water of the mere in the distance all white as this was catching the light.

4. While everything was still damp, I mixed some Light Red and Cobalt Blue to give a suitable light grey for the cloud colouring which was near the horizon and for one grey cloud on the right-hand side. The mere water had some grey run into it as well.

The sky work was now finished and was allowed to dry out completely before continuing with the remainder of the picture.

Now having looked at a sunny blue sky, let us consider a cloudy one. Figure 19 shows in monochrome a rather subtle *Late afternoon sky over Norwich Cathedral*. The area behind the spire is in fact a very pale blue using a watered-down Winsor Blue, and the light areas of cloud are very pale Raw Sienna giving an evening glow. The darker clouds are a mixture of Ultramarine and Burnt Umber, and you will note the clouds to the left have vertical rain coming down, indicated by dry

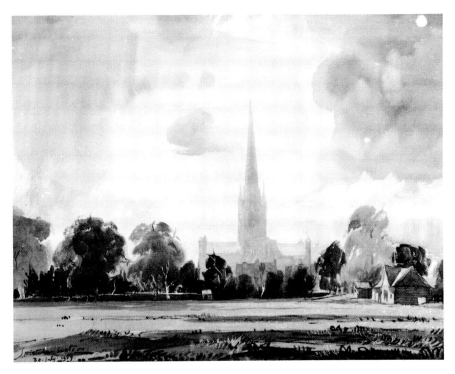

19 *Late afternoon sky over Norwich Cathedral* 368 x 470 mm (14½ x 18½ in)

brushwork being dragged over the damp paper from the previous wash.

We are looking at the east end of the cathedral and the sun is beginning to get low in the west which throws the building with its spire into silhouette.

The sky painting was started with a wash of clear water, as in the previous picture, but only a damp wash not a heavy wet one. Everything was kept slightly damp throughout the sky painting so that there should be no hard edges.

The paper used was Ingres which was pale ivory tinted. This is a paper mainly for pastel use and is rather lightweight, but when stretched, as it was in this case, it takes watercolour extremely well.

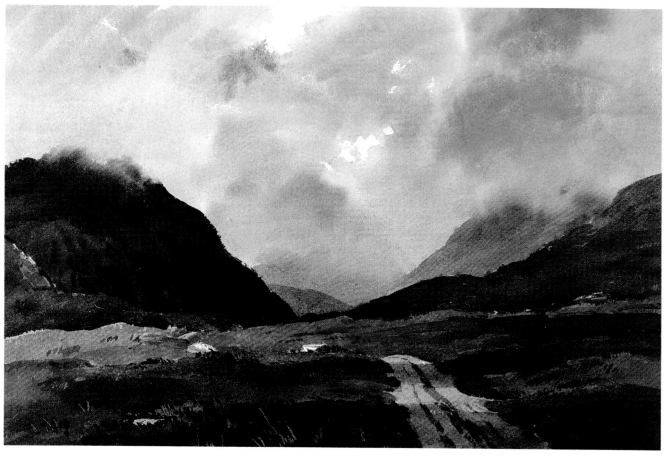

20 *Stormy sky in Glencoe* 317 x 476 mm (12½ x 18¾ in)

Now I will show you how to paint a really heavy stormy sky, and Figure 20 shows this in the picture *Stormy sky in Glencoe*. One so often gets most exciting skies in the Highlands of Scotland, and of course such skies as this are changing all the time, so that even when painting on the spot, as I was in this instance, you have to memorise a particular cloud formation. They do repeat themselves with, for example, a patch of blue appearing in a different place, so it is not so difficult as it sounds.

The painting work proceeded as follows:

1. I was using Arches 300 lb NOT surface paper and I first drew with a pencil, very lightly, the mountains and road outlines. (Incidently the composition of this picture was most attractive.) I then dampened the sky area with clear water.

2. Using Payne's Grey I floated this colour in all over the place, making it darker or lighter as required by adding water or more paint to the mixing dish. I introduced a small area of yellow using Raw Sienna just off centre to the right, as you can see. You often get this colour in rather threatening thundery skies.

3. While all was still quite damp, I introduced two patches of quite strong pure Ultramarine, one large patch and one small one. These ran into the grey clouds nicely. I had left a piece of white cloud at the top which was the white of the paper.

4. You must note the fact that I had carried the cloud washes *down well over the mountains* and the whole sky was then allowed to dry out completely.

5. The far distant mountain in the centre was next painted a light grey-brown, and with a *separate brush* I dampened the sky area above it with clear water, allowing the brown mountain wash to run into it to create the appearance of low cloud on top of the mountain.

I then repeated this technique with the dark brown mountain on the left and the yellow mountain on the right. This gave the impression of low cloud softly hovering on the mountain tops as it so often does.

I advise you to practise this technique on a piece of paper that is not an actual painting to get the idea of painting a mountain colour *upwards* into a damp clear wash. I say more about this technique in Chapter 7 on mountains.

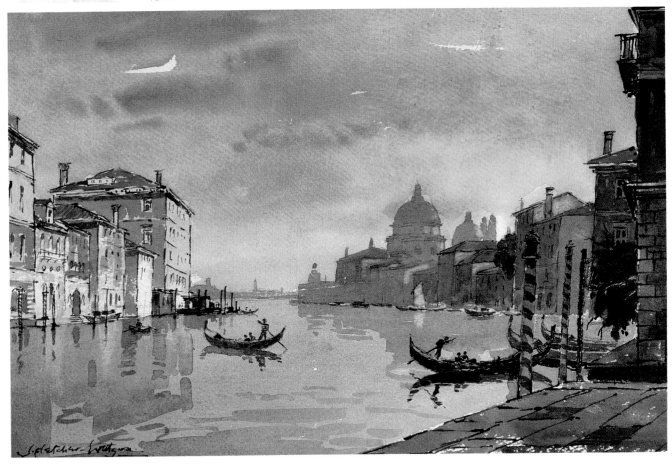

21 *Evening sky, Venice* 317 x 476 mm (12½ x 18¾ in)

Next I would like to tell you about evening skies. They can be so attractive with unusual colouring, so let us look at *Evening sky, Venice* (Figure 21).

Venice is such a magical place that any sky will look nice, but as evening draws in it all becomes very romantic and poetical.

I will describe the painting of this sky in detail.

1. The drawing of buildings had first to be made and I used a B pencil and Bockingford paper 250 lb. I also used pen and ink on a few buildings. The position of the horizon was in the proportion of two-fifths to three-fifths of sky.

2. Without wetting the paper with clear water, I put on a wash over the whole sky of Raw Sienna with a small addition of Light Red to the mixture. This was a *graded* wash starting with dark at the top and making it paler as we came down by adding water in the mixing palette. I made it a little pinker at the very bottom by adding more of the Light Red.

3. Now some Light Red by itself was painted half way up on the right where thin cloud was catching the sun, and also a delicate brush stroke of Cadmium Yellow was put in at the centre.

4. Finally some yellow-grey clouds at top left were painted with a No. 8 brush using a mixture of Raw Sienna, Light Red and Cobalt Blue. The original wash was still damp so all the washes were soft and blurred. The important thing is not to have the subsequent applications too wet; they must be almost dry brushwork painted into wet.

In the next chapter in Figure 28 we have a sky of cumulus clouds going away in perspective with touches of blue sky here and there, and in Figure 36 in Chapter 6 there is a good example of placid light grey clouds with small areas of light blue. In Figure 68 in Chapter 9 we have a Scottish sky of mainly light blues and greys but with some small darker grey low clouds floating in.

There really is no end to the variety of skies, with clouds or without clouds, and with careful observation (and, hopefully, using the knowledge I have tried to impart to you) I think you will find you can progress towards painting some really good skies.

I have often painted skies with no landscape at all just for practice, and of course we all know that Constable painted many, many sky studies like this.

5 How to paint distance middle-distance and foreground

Almost every landscape country scene that we paint has these three divisions of areas, and when I am carrying out a demonstration I ask my painting friends to half close their eyes and mentally divide the scene into (1) *distance*, (2) *middle-distance* and (3) *foreground*. There are, of course, in nature itself many more sub-divisions, but for simplicity and learning how to paint in three dimensions – height, width and depth – it is a very good rule to apply.

Look at our first picture in this chapter – Figure 22 showing *The Honister Pass, Cumbria.*

1. We have *distance* in the form of the light grey mountain in the centre and the not so distant steep dark hill on the right and the pale green hill on the left. There is also the thin grey road twisting up through the pass.

2. Then we have the *middle-distant* massive lump of rock on the yellow-green grass with smaller rocks round it.

3. And finally we have the *foreground* of the moving stream with loose rocks and green turf with dark green reeds.

The average person looking at this picture would simply see a pleasant looking mountain view with great depth in it inviting them to take a walk over the turf into the far distance. Well that is the result we are striving to produce.

But it is all achieved by basic good drawing and sound tone

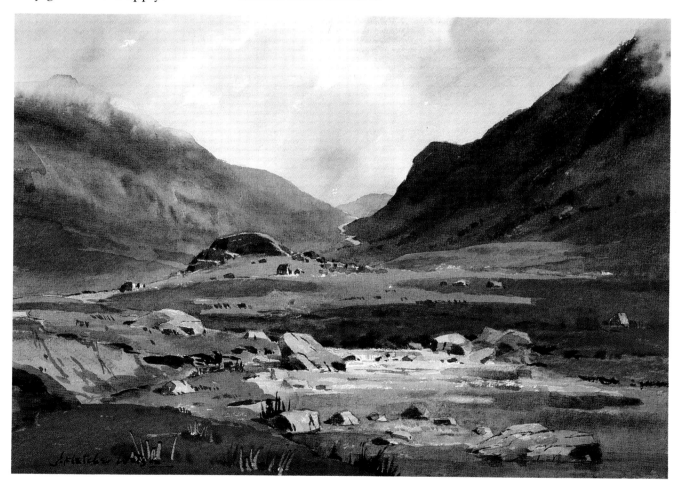

22 *The Honister Pass, Cumbria*, 317 x 476 mm (12½ x 18¾ in)

values. The very far mountains are a very light tone, only just darker than the sky. But the distant items do not always have to be the lightest, and the craggy mountain outline on the right is as dark as some of the items in the foreground, owing to cloud shadows over it; also, because of the sun being on the right side, the whole right-hand mountain is in shadow. Furthermore the higher parts of the mountain are bare rock which gives it a darkness.

The sun is catching the middle-distant ground so this has to be painted a light colour. It is also catching the rocks in the foreground and some of these are left almost the white of the paper.

A few of the low clouds are coming over the mountain tops to left and right and this always has the effect of emphasising their height, which is all part of the three-dimensional effect we are trying to obtain. We have, I think, obtained an atmosphere of grandeur and depth which is so often apparent in mountain scenery, and it has all been done by keeping a strict eye on the *system* of dividing the picture into three groups.

Now I am not going to describe the actual painting of the picture,

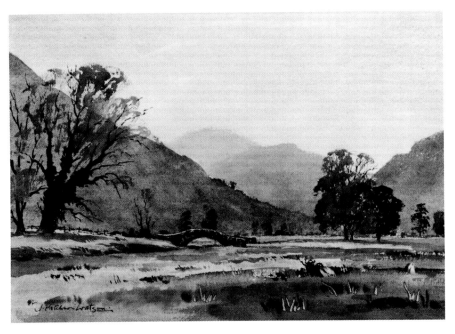

23 *Borrowdale, Cumbria* 317 x 476 mm (12½ x 18¾ in)

as I was simply using it to illustrate the principle of dividing a landscape into three clearly defined areas of depth. You can now apply this idea to any landscape you undertake.

In Figure 23 we have a picture of Borrowdale, Cumbria showing a view painted in late morning with the sun in my eyes, thus silhouetting the mountains and the little foot bridge and the trees. In this morning light the division of *distance*, *middle-distance* and *foreground* is even more clearly shown. There is a cloudy sky and

the far mountains are slightly blurred in the morning mist, whilst the left-hand mountain in the middle-distance is darker and clearer as also is the right-hand group of trees. The left-hand ivy clad tree, the bridge and the near areas of grass and small rocks are in the foreground area and they stand out with darker stronger paint treatment.

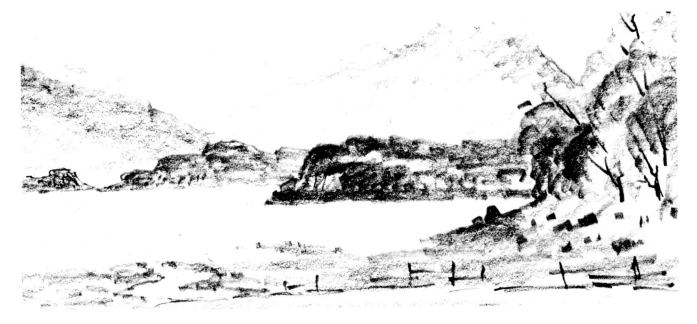

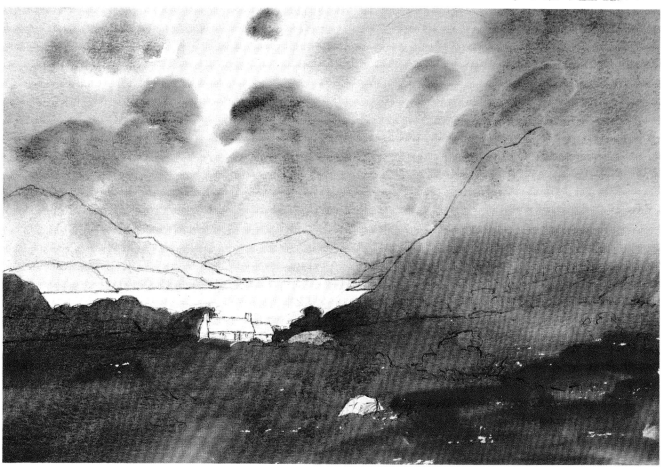

24 *Loch Maree, West Highlands of Scotland,* Stage 1 317 x 476 mm (12½ x 18¾ in)

I cannot emphasise this business of dividing your landscape into three parts too strongly as it is the secret of producing a successful picture; so I will now describe in detail the actual painting of the next picture. Figure 26 shows the finished painting of Loch Maree, West Highlands of Scotland, and Figures 24 and 25 show the stages leading up to the completed work.

These painting stages are not necessarily grouped into distance, middle-distance and foreground because with watercolour we have to paint the light passages first and the dark passages last.

Stage 1

1. I used Whatman NOT 200 lb paper and a 2B pencil and first drew in the loch and mountain outlines and the thatched cottage and the rock in the foreground.

Then the sky was dealt with, wetting the area first, and then running in the cloud shapes with Payne's Grey and washing this grey *right over* the mountains down to the water line of the loch. (A lot of people seem to find this difficult and want to stop their sky wash at the top edge of the mountains. This is a fatal thing to do and leads to a lot of trouble with marrying up the mountain wash later.)

I now dropped in some areas of blue sky using French Ultramarine and a small area of diluted Raw Sienna low in the sky.

2. The whole sky wash was still wet and I quickly mixed a yellow-green using Raw Sienna and a touch of Winsor Blue and painted this on the right-hand mountain, joining it with the grey sky wash and bringing it round onto all the foreground area and skirting the loch so that this was left the white of the paper. This completed Stage 1. What could be simpler? It was all allowed to dry out.

39

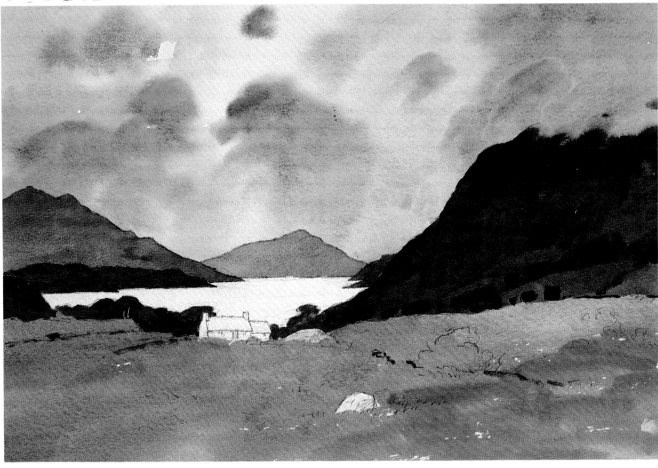

25 Stage 2

Stage 2

3. The far distant mountain must be dealt with first with a simple flat wash of Ultramarine and Light Red giving us a nice grey-blue colour but keeping the tone value really light.

4. Then the mountain on the left was painted using the same two colours but adding a little Burnt Umber to give it a darker tone. When this was nearly dry I touched in the low headland which overlapped this mountain. I used a mixture of Ultramarine, Raw Sienna and a little Burnt Umber for this headland which was a brownish green in colour, the tone being a little darker still than the previous mountain.

5. There are two small headlands sticking out on the right-hand side of the loch which were painted the same brown-green as the item just mentioned.

6. Now the big mountain on the right was washed in with a larger brush – about a No. 10 – and I mixed Burnt Sienna and Winsor Blue for the basic wash which was a rich brown-green colour. When I came near to the top of the mountain I added in some Burnt Umber to darken the tone and colour and dealt with the cloud coming over the mountain by using clear water and a different brush, all as described in Chapter 7 on mountains. As this wash dried I added in with a No. 7 brush a few strokes of stong Burnt Sienna indicating areas of brown bracken. (This picture was painted in the autumn.)

7. The dark small tree groups at the foot of the mountain were put in at this stage; they consisted of strong Burnt Sienna and Winsor Blue.

The other trees behind the cottage and over to the left were painted next using variations of Raw Sienna, Winsor Blue and Burnt Sienna. Thus stage 2 was completed.

Stage 3

We now have only the cottage and the foreground to finish, so we have to a large extent been conforming with the divisions of distance, middle-distance and foreground.

8. I wanted to paint the cottage first with its thatched roof which was a grey-brown obtained with a mixture of Burnt Sienna and Cobalt Blue. Then a very light wash on the right-hand wall of the cottage with Cobalt and Light Red gave a grey shadow colour. The sunlight was coming from the left so this wall was a slightly darker tone than the white wall

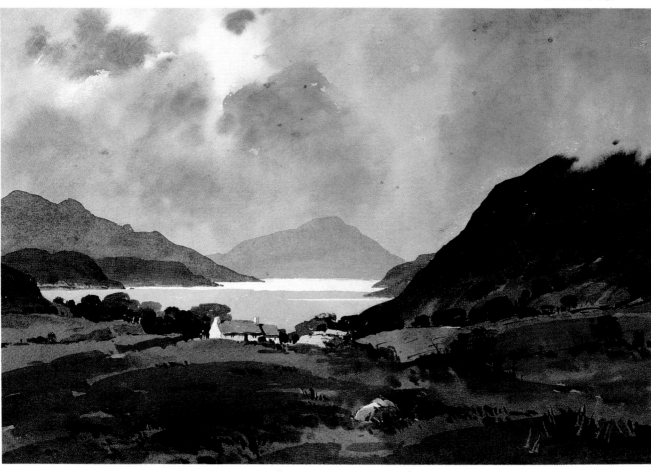

26 Stage 3

of the gable. Chimneys also received grey to their right sides. When this was dry the dark shadow under the eaves was painted using Cobalt and Burnt Sienna. Again this must dry before we could put in, with a small brush, the dark windows and door with Ultramarine and Burnt Umber.

9. Now the big rocks by the cottage and the close-up foreground rock received grey shadow touches of Ultramarine and Indian Red mixed together.

10. Some of the dark bushes and shrubs were now painted with a mix of Burnt Umber and Winsor Blue and also various tufts of grass. And then I swept in the cloud shadows over the grass using a No. 10 brush, the near foreground washes first and then some narrower lighter shadows further away. I used a

mixture of Burnt Sienna and Winsor Blue for these, varying the tones as required.

Lastly I added some strength to the closer tufts of grass and scraped with a sharp penknife blade a few individual grasses on the right-hand side to give additional texture.

11. But one final item remained, the water, which was still untouched, the white colour of the paper. This received a single wash of medium light Payne's Grey leaving a white area in the distance which was catching the sunlight.

I should tell you that the finished picture as shown at Stage 3 was painted on the spot, and Stages 1 and 2 were painted on a separate sheet of paper in the studio in order that they could be photographed at these early stages. You may, therefore,

notice some slight discrepancies when comparing the three illustrations. The clouds, for example, are not quite identical and parts of the mountain outlines are not quite the same, but this does not matter as what is really important is my telling you the order in which things were painted and how the washes were laid on and what colours were used.

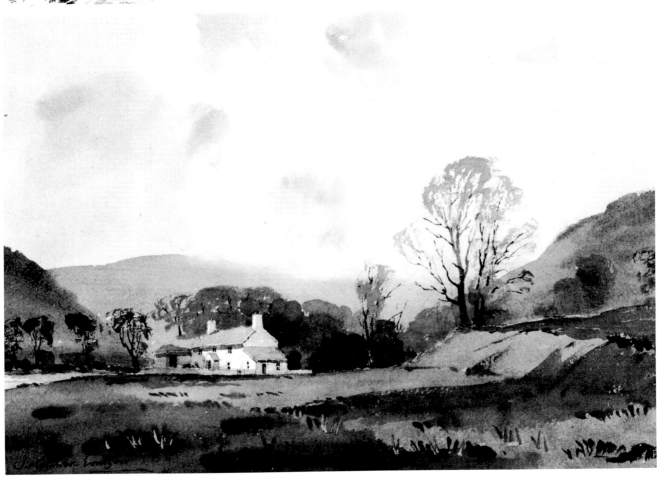

27 *Below Cader Idris, Wales* 317 x 476 mm (12½ x 18¾ in)

I would like you to look at a few more examples of distance, middle-distance and foreground, and refer you now to *Below Cader Idris, Wales* (Figure 27). This picture shows a not very distant hill with low cloud touching the top. The tone of this hill is light and this keeps it well in the background. I could actually see rocks and marks on it but I resisted touching it with any mark at all.

Then in middle-distance we have the farmhouse with dark trees behind and a large tree on the right.

The foreground is quite simply a grass field made to look interesting with shadows and lumps of grass here and there.

This composition illustrates in a very simple way the three areas of depth we are talking about in this chapter.

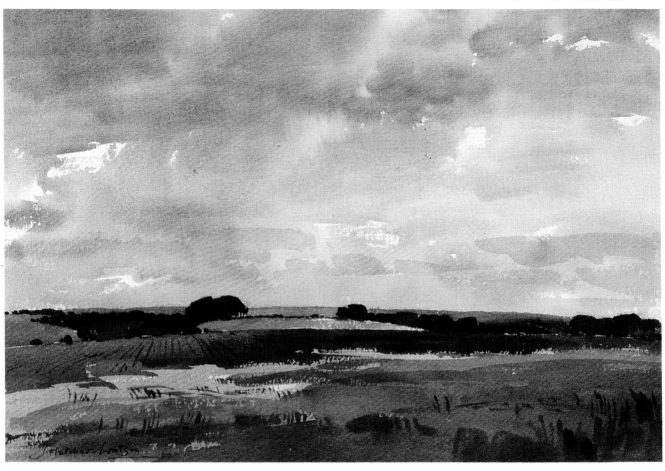

28 *Above Bower Chalke, Wiltshire* 317 x 476 mm (12½ x 18¾ in)

An interesting example showing the emphasis on distance only is Figure 28 which shows a view above Bower Chalke, Wiltshire. The distance is the grey-blue steak of very distant hills and the blocks of dark woods along the edge of the yellow field and to right and left of it, which are not quite so distant.

The middle-distance is the dark brown field, and the foreground is, of course, the buff coloured stubble close-up with the brownish cloud shadow falling across it.

A sky is always a continuous process of near, medium-distance and far away whether it be an all blue sky or a cloudy sky. In this case the clouds add to the general perspective as they decrease in size towards the horizon.

With this picture the eye is drawn first to the far distance, whereas in most landscapes the eye tends to go to the middle-distance first.

Figure 29 shows a picture of *Windrush Village, Glos.* from across the fields to the south, and a lovely subject it is. The main interest is the church and cottages in the middle-distance, but I want to tell you how the *distance* was painted. All too often I find painters putting in *too much detail* in the distant areas. That is because they have forgotten the trick of half closing their eyes. In this picture there are woods and stone walls and trees in the distant hill, but to give a proper feeling of distance these items have been reduced to very simple terms.

When painting this distance I first laid on a flat wash of Ultramarine and Light Red, giving a warm blue-grey. As this wash dried out I ran in a *not too wet* wash of Raw Sienna and Winsor Blue, which gave a yellow-green colour, and this was applied to the lower area of the hill. While everything was still damp I mixed a dark grey colour and with a No. 4 brush painted in the woods and trees and indicated stone walls with a few quick brush strokes. If you look at the picture you will see that the effect is of a far-away hill with a suggestion of woods etc., which is all that is needed; your imagination can do the rest.

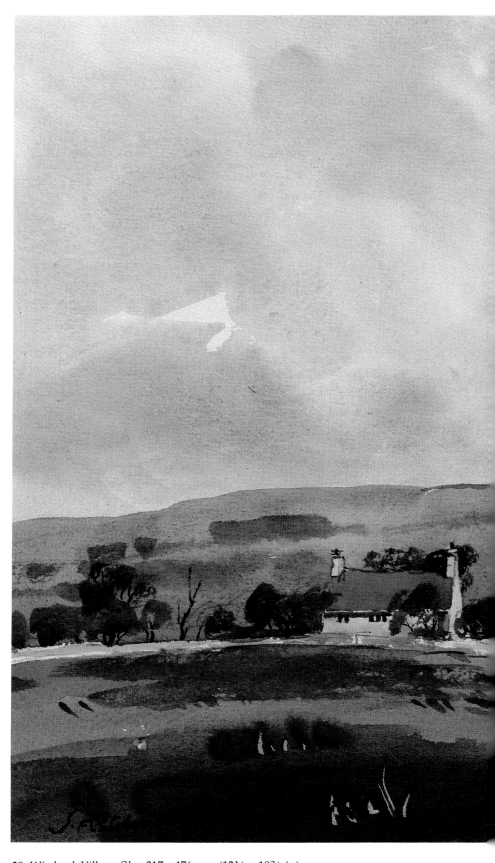

29 *Windrush Village, Glos.* 317 x 476 mm (12½ x 18¾ in)

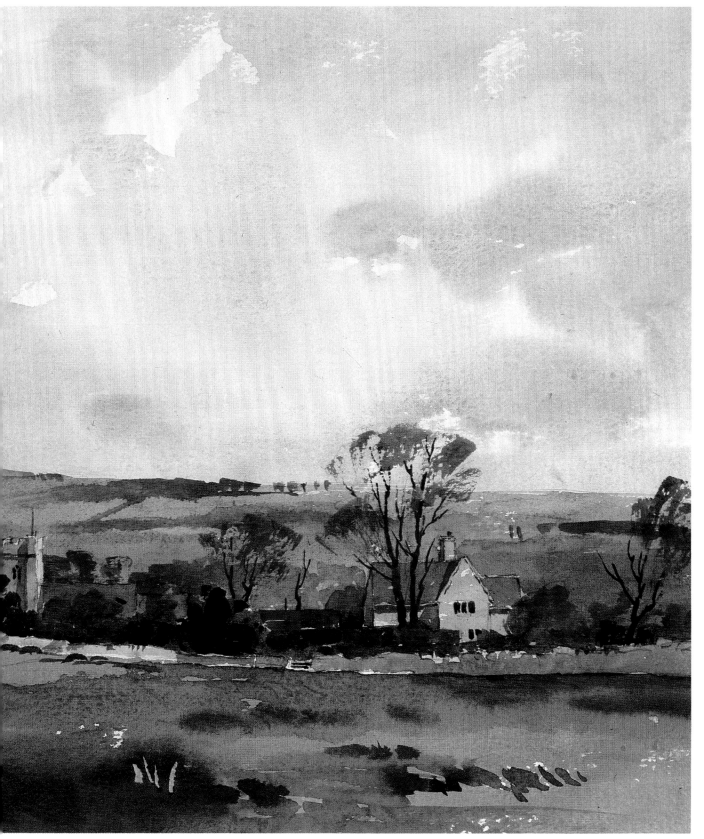

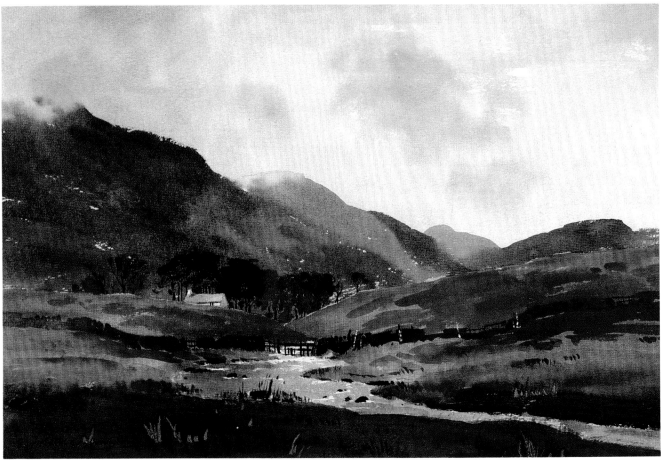

30 *Gatesgarth, Cumbria* 317 x 476 mm (12½ x 18¾ in)

Back to a mountian scene now, *Gatesgarth, Cumbria* (Figure 30). I wanted to concentrate on the middle-distance here, which is the block of trees and the cottage and also the drop gate in the stream. There is a lot to look at in this picture, the steam and stone walls and the imposing range of mountains with cloud shadows picking out some of them in dark tones and others being in sunlight. But the eye is first taken to the cottage and dark trees – or does it go to the drop gate in the water? Whichever it is these two items form the focal point and are painted in strong tones of colour. They are forming the middle-distance and holding the attention. All other items in the picture are subservient to the middle-distant groups. This is what a good picture should have and I would like you to

remember this 'focal point' element whilst you are also planning your picture recession in three groups.

Now for a close-up river view, which we have not had in this chapter so far: *On the Windrush river, Glos.* (Figure 31). It should not be necessary for me to tell you how this picture divides into three. The distant hill and nearer belt of trees is in the distant category; the large tree on the edge of the river and the cows are in the middle area, and the foreground consists of water with tree reflections and river bank.

The point to emphasise here is the strong tone of paint work for the big tree; the eye is immediately caught by this and its strong colour makes the background trees fall away, as one wants them to.

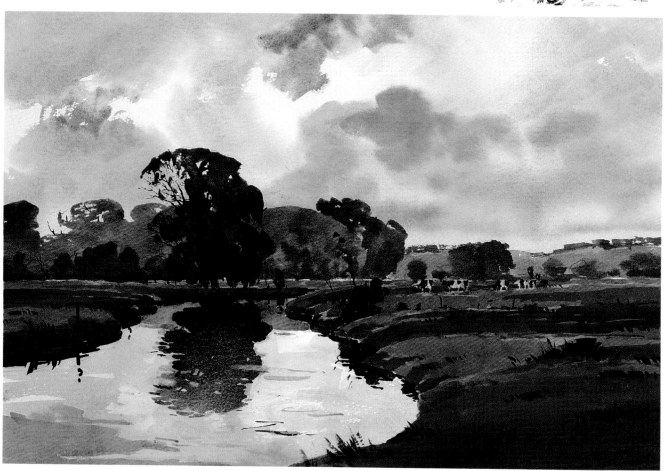

31 *On the Windrush river, Glos.* 317 x 476 mm (12½ x 18¾ in)

Glen Shieldaig

Next I would like to show you another view close to a river: *Windmill on the Thurne, Norfolk* (Figure 32). There is a very thin grey line of distant marsh land and that is all far in the distance. The mill, trees and shed constitute the middle-distance, and the reeds and low trees on the left and the near bank form the foreground. This is a simple enough picture and yet we achieve quite a feeling of depth by giving detail and texture to the foreground grass and treating the remainder with unfussy brush strokes.

You may be saying to yourself that we have not seen a proper architectural subject showing the three areas of distance, so here is one in Figure 33 showing Chilmark, a Wiltshire village of stone and thatch.

There is hardly any distance at all in this picture, which often happens in a buildings subject – just the one tree painted rather faintly seen immediately to the right of the main central cottage.

The central thatched cottage and the one on the right and the dark tree beside it are the middle-distance.

The stone garden wall in the centre with dark shrub against it and a small portion of building make up the foreground objects. The three areas are all quite clearly defined if you look for them, but of course the general effect is a village street with depth and a good three-dimensional quality.

With my last two illustrations I would like to concentrate on foregrounds, as I find a great many students and even mature painters are weak on this subject. Nothing is worse than a blank foreground that falls out of the picture; this does not mean that it has got to be crammed with detail, but it must somehow be made to come right up to you.

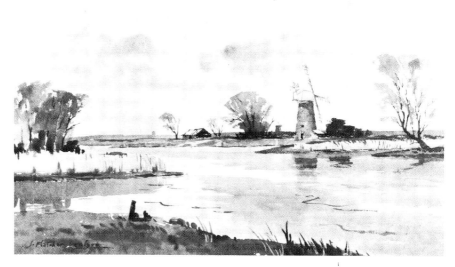

32 *Windmill on the Thurne, Norfolk* 317 x 476 mm (12½ x 18¾ in)

33 *Chilmark village, Wiltshire* 317 x 476 mm (12½ x 18¾ in)

Let us look at Figure 34 which shows a lovely Lake District scene with a rugged rough grass foreground that you feel you could really tread on.

One of the rocks has a dark bush behind it with twigs sticking out; this gives a good close-up feature, and the light coloured stone of the rock is made to stand out owing to the strongly painted dark bush behind it. You want to look out for such features when selecting your view point right at the beginning. It is an important part of composition to endeavour to have a good foreground for your picture. The other rough grasses and chunks of heather help to give detail and closeness without overdoing it. We do not want to see every blade of grass put in, since it would then become fussy and destroy the impressionistic style at which we are aiming.

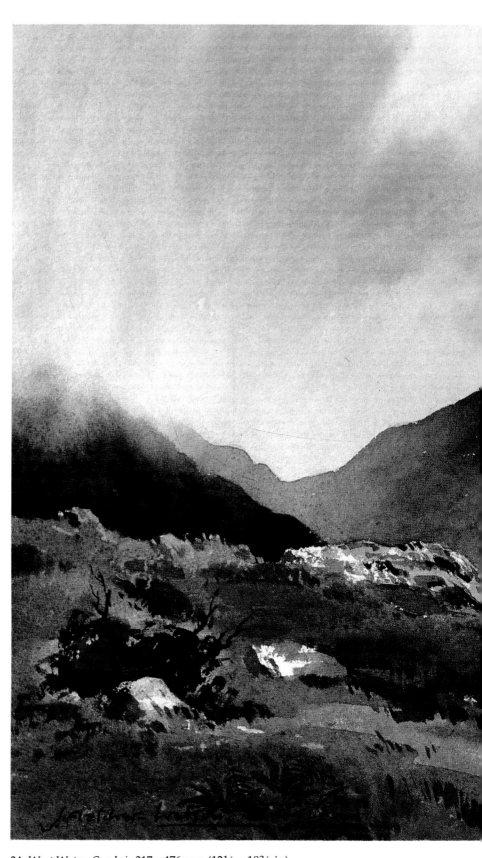

34 *Wast Water, Cumbria* 317 x 476 mm (12½ x 18¾ in)

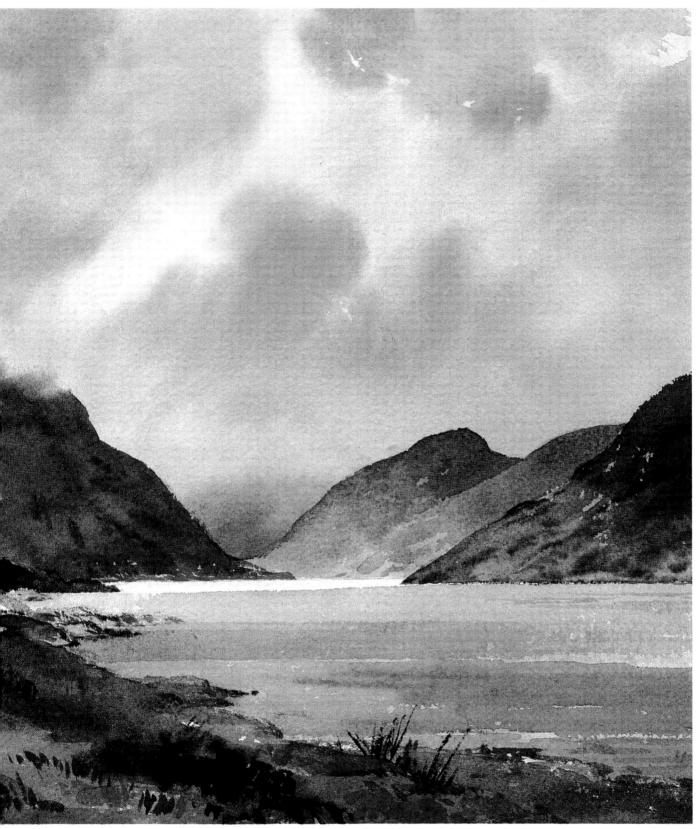

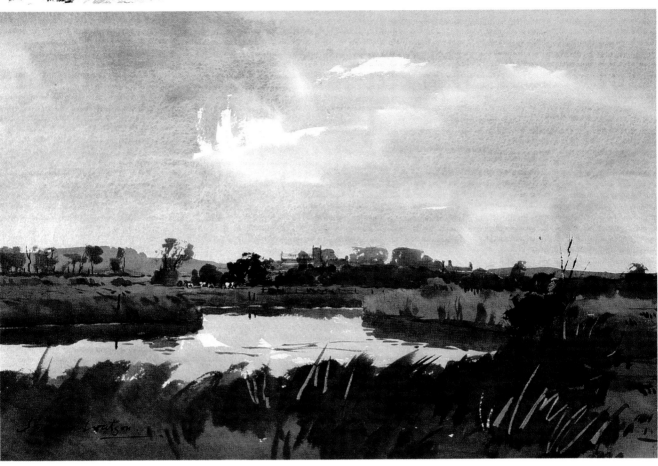

35 *River Glaven, Norfolk* 317 x 476 mm (12½ x 18¾ in)

The other picture is Figure 35 showing a Norfolk river with thick long grass and some green reeds in the foreground. This mass of growth was painted with a large brushful of a green mixture of Raw Sienna and Winsor Blue and was applied with quick brush strokes. With the point of the brush I painted upwards to give a sharp point to some of the long grass. When the paint was nearly dry I used my penknife, scratching out some reeds on the right. I think the general treatment gives a good strong foreground which effectively sets back the river and middle-distant village church, etc.

6 How to paint estuaries and mud flats

This is a fairly narrow range of subject and will therefore be a short chapter, but it is an extremely important one. Some of the most beautiful and peaceful subjects can be found in river estuaries. This is an item that could have been included in Chapter 3 about *choosing* a subject, but a lot of people have discovered estuaries and have asked how one gets the feeling of *mud* and the stillness and peace which so often goes with this subject. Well, if you have got the right approach it is not difficult to paint these subjects. The great thing is to learn to 'leave out'.

Looking at Figure 36 we have here a late afternoon painting, done on the spot, of the Barmouth Estuary, Wales. The Welsh mountains are low near the coast here and they made a lovely soft background, and I *very* lightly drew them in on Bockingford paper. I then painted the light grey and blue sky with wet washes and added Raw Sienna near the horizon.

When the sky was nearly dry I touched in the most distant mountain in a light blue-grey, and when everything was dry the other mountains and headlands were painted with their varying shades of blue, green and brown. It was important to get the waterline right with the gradually receding promontories.

Up to now the bottom half of the paper was left white and I could paint in the various mud flats, not having marked them

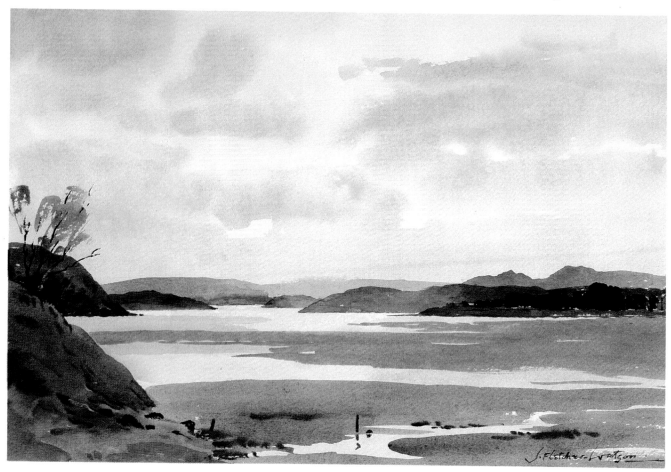

36 *Barmouth Estuary, Wales* 317 x 476 mm (12½ x 18¾ in)

with a pencil *at all*. I had to be quick as the tide was coming in and the shapes were changing all the time. The sandy mud was a variety of lovely colours all obtained with various mixes of Burnt Umber and French Ultramarine (see Figure 7, mixture 7). With a fully loaded No. 8 brush I painted the light brown flats, sweeping the brush quickly from right to left across the white virgin paper. Then with a No. 10 brush I painted the blue-grey foreground flats, moving the brush from left to right this time in quick strokes and using plenty of water with the mixture. Then these washes were left alone except for a few dark brown marks put in on the foreground.

When this was all dry I could paint the left-hand steep high bank with the saplings standing up vertically, touching in a few rocks and the vertical post in the mud with its reflection.

The picture was finished quickly with such direct painting and little detail. It is one of my favourite pictures and I was reluctant to let it go at my last exhibition. But there are plenty more estuaries just waiting to be painted, and I hope you will all attempt this type of subject and remember to slosh on the paint with plenty of water and a steady hand!

I am showing you another estuary in Figure 37. This is a much smaller one, entitled *Low tide, Morston quay, Norfolk*, and what a coast this Norfolk one is – just full of subjects for the watercolour painter. In this picture I had a fairly stormy sky, painted with Payne's Grey and Raw Sienna, but there were gleams of sun now and then to light up the marshes.

The mud here in Norfolk was a darker blue-brown in many places than it was at Barmouth, but I used the same two colours for painting it. This subject is the type of thing an old painter

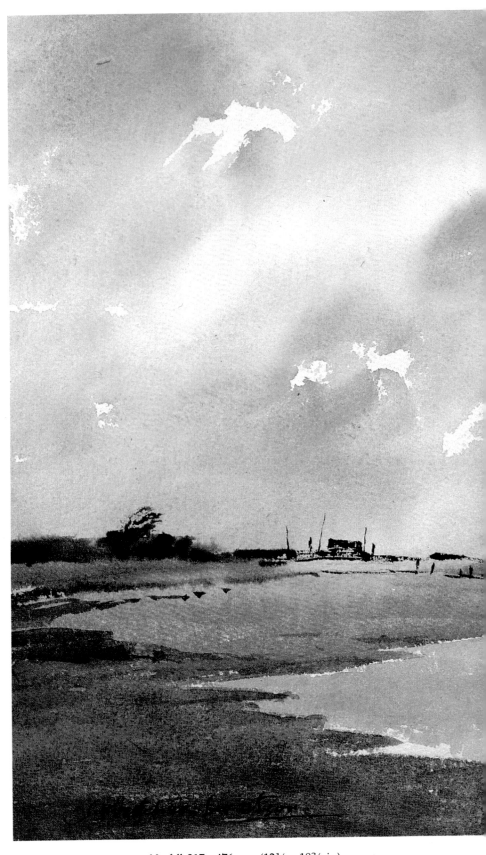

37 *Low tide, Morston quay, Norfolk* 317 x 476 mm (12½ x 18¾ in)

friend of mine, Edward Wesson, would call 'Bags of damn all'! A wonderful wet-watercolour

painter Edward was and how right he was with his description. You really feel alone with nature

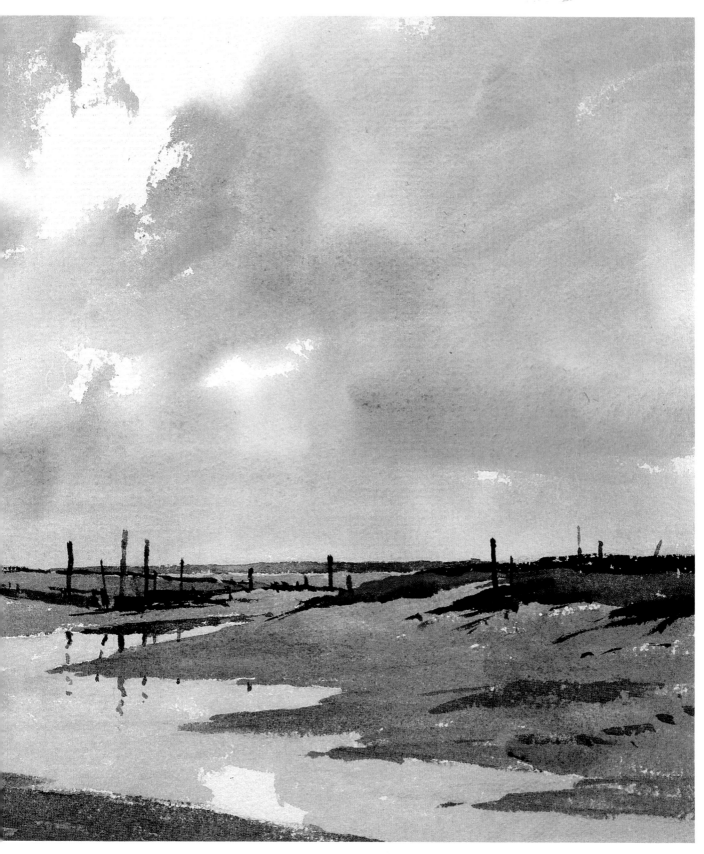

with this sort of subject.
 I used the same technique of
direct wet washes and very little
pencil work.

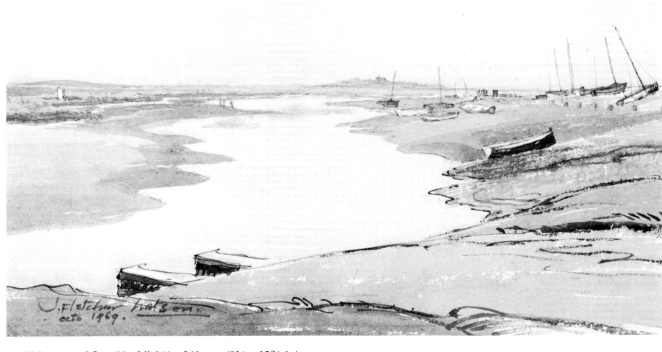

38 *Blakeney mud flats, Norfolk* 241 x 349 mm (9½ x 13¾ in)

If we move a little further east along the Norfolk coast from Morston we come to Blakeney, where I show you in Figure 38 the mud flats when the tide is out in the little creek. There are a few sailing boats which get left high and dry at low tide, and they help add perspective to the scene.

This was an evening picture with a dull yellow sky which reflected in the water. The mud was a rather sandy-brown here so the whole picture took on a monochrome look in greys and light browns. I painted it on an old piece of David Cox paper which was biscuit colour, and it suited very well. If one wants a tinted paper, it is always possible to put a flat wash over white paper of, say, diluted Burnt Umber and let it dry before using it. Turner did this preparing of paper with a tone of colour a great deal.

I used a little pen work in the foreground of this picture to sharpen up and bring into focus the nearer areas of mud banks and boats.

I hope I have told you enough about how to paint estuaries; there is not really much to tell as they are such simple subjects, but these simple subjects are so often the best. The key to the matter is to use direct washes on virgin paper and then leave them alone and don't go and spoil it by fiddling with an unnecessary detail that could well be left out.

7 How to paint mountains

I have said much about painting mountains in my books but I have never had the chance of demonstrating a mountain painting on the spot. I cannot quite do that in this book but what I will do is to show you three separate illustrations, one of each stage of a mountain picture, so that we can go into the painting methods in detail.

There is a lot of mountain scenery to choose from in Britain: Scotland, Wales, the Lake District and each of these areas have different characteristics. Travelling to Europe, and further afield, does, of course, increase the range of scenery and provide even greater possibilities.

I would like first to take a general look at some mountain pictures and we will start with *Tal-y-Llyn, North Wales* (Figure 39).

Mountains usually run in groups of several at a time and the question of *composition* is extremely important; to select a good composition is going to make an enormous difference to your painting. It is quite easy to select a *bad* composition by not looking at your subject carefully enough at the beginning. I took a long considered look at Tal-y-Llyn before I decided on the exact viewpoint. The dip in the mountains where a road goes through the mountain pass was a key factor and focal point, and one had to decide whether to have this to the left or the right or even in the centre of the picture. I decided to have it to the left so

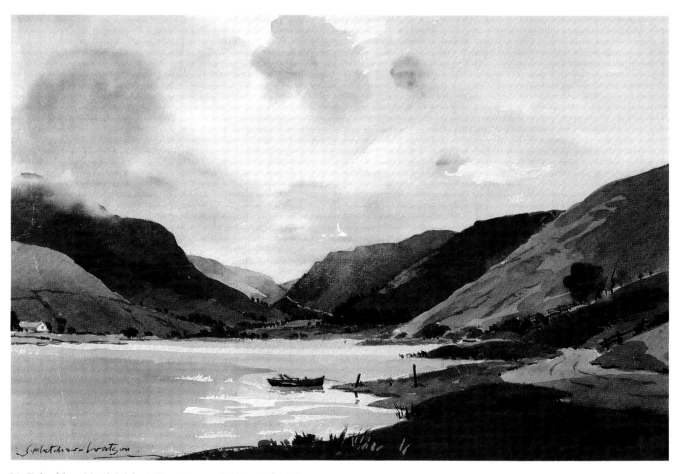

39 *Tal-y-Llyn, North Wales* 317 x 476 mm (12½ x 18¾ in)

that I could include the interesting edge of the lake and the road to the right; these items would adjust the balance nicely. The position of the boat played an important part also. If you have got your composition right you are almost half way there as far as painting a mountain is concerned.

The other thing is, of course, *lighting*. The type of day and the amount of sun, if any, play a vital part in the success of a mountain picture. In mountainous country there are not many days without cloud, so you are fairly safe to count on them.

The day this was painted was excellent; there was enough cloud to give some dark shadows on the mountains but there were breaks in the cloud with blue sky and enough sun to light up some areas of mountain and road and make it all interesting.

The light changes while you are painting and you must therefore observe what arrangement of light and shade you like best and memorise it. You cannot change your mind half way through.

Having drawn the main outlines on my Bockingford paper and got the edge of the lake pencilled in, I painted the lovely cloudy sky using Payne's Grey and a little Raw Sienna, and Cobalt for the blue patches. The wash was taken right down to the lake side and in fact over the lake as well, just leaving a few white areas at the bottom part of the water. So I had in fact covered the whole paper with a light grey wash.

When this was all dry I could first paint the distant mountain in the dip and this I had decided was going to be in sunlight not shadow, so it had to be an extra light shade of green-grey. The time of year was May so green was predominant, rather than brown and blue as is the case in the autumn. Actually there was a small triangle of very distant

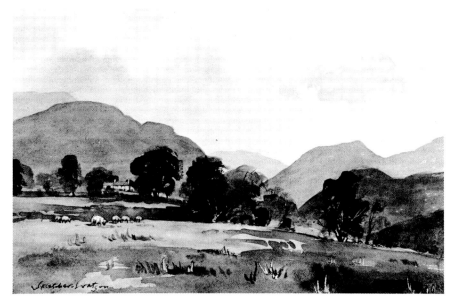

40 *Newlands valley, Cumbria* 317 x 476 mm (12½ x 18¾ in)

mountain that I painted grey-blue, and if you look carefully you can just see this. I then proceeded to cover all the mountains with light washes of green or brown, as appropriate, and extended the light brown wash over the road and foreground. This picture was a case of building up washes covering big areas not just individual mountain shapes. The shapes would be brought out in a further stage when applying the cloud shadows. This work I carried out next, but not including the foreground shadow which I painted last.

Now the various tree groups could be applied. The belt of trees slightly to the right of centre was the darkest and this gave a nice emphasis just where it was wanted.

Lastly the foreground shadow, the water and the boat were dealt with and you will notice how helpful the two posts are to the composition.

Now we can look at Figure 40, *Newlands valley, Cumbria*. Here again we have a number of mountains which are a warm blue-grey colour as it is evening light and I am looking into the sun. The mountains in this case are of secondary importance as they form a back drop to the interesting groups of trees and the distant farmhouse and also a few sheep. The clouds are high and do not overhang any mountains.

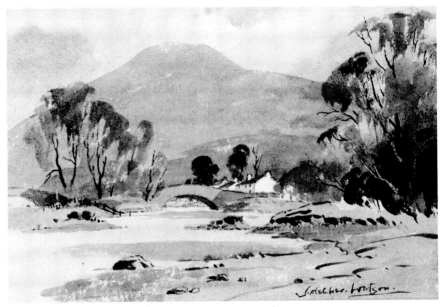

Turning to Figure 41, *Grange bridge, Cumbria*, here we have a *single* mountain as a backdrop and again it is not of main importance, the primary interest being the bridge and cottages and trees. This is a good composition with the high trees on the right foreground effectively balancing the middle-distance details.

41 *Grange bridge, Cumbria* 242 x 356 mm (9½ x 14 in)

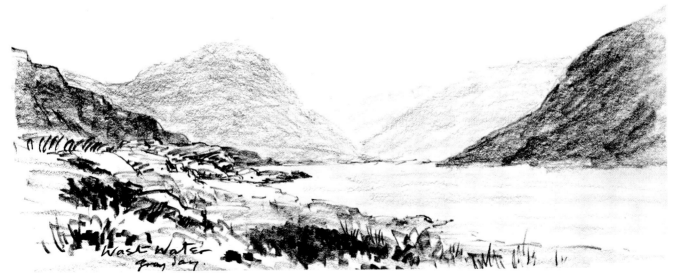

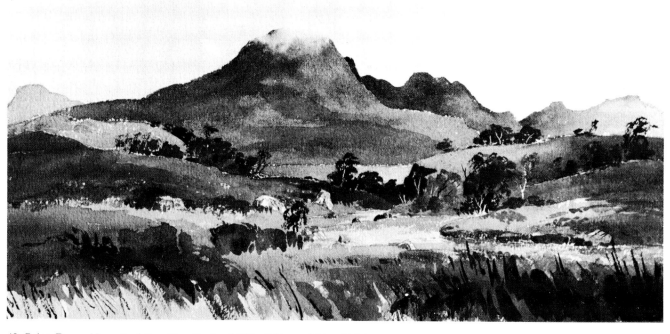

42 *Beinn Dearg, Upper Loch Torridon, Scotland* 235 x 356 mm (9¼ x 14 in)

Going now to Scotland we have a view where the mountains *are* the main feature, and we concentrate on *one* mountain, namely Beinn Dearg, Upper Loch Torridon (Figure 42). It is unusual to have an almost clear sky with just a small white cloud touching the top of Beinn Dearg. There are, of course, quite a lot of foreground and middle-distance features – the loch, trees, rocks, the river and some reeds – but somehow the mountain still dominates the picture.

I will now describe, in detail, the painting of a mountain

landscape picture, namely *Farm at Abergynolwyn, North Wales* (Figure 45).

This is a really lovely subject that appealed to me directly I saw it. I was right in amongst the mountains and sitting by a mountain road which gave a perfect foreground, with the sloping ground falling away to the right.

Painted in early May, the grass on fields and foothills and higher up the mountains too was beginning to look green, but the cloudy day gave a brownish-green look to some areas and the far off mountain was quite grey.

We must first look at Figure 43 which shows Stage 1 of the picture.

1. I decided to use Bockingford 250 lb paper and I first did some careful thinking about *composition* – always the first item which must be considered. The little farm cottage should obviously be positioned to the left in order to open up the view of the river and mountains going away to the right.

I did my usual thing of drawing an invisible picture with my finger to get the various features in their right relationship to each other, and then I set to work drawing with a B pencil the foreground slope and the cottage and sheds and an outline of the mountains beyond, and of course the river was drawn rather carefully, to get its perspective right. I was careful not to draw a line on top of the two mountains where cloud was

43 *Farm at Abergynolwyn, North Wales,* Stage 1 317 x 476 mm (12½ x 18¾ in)

coming over. You will notice this if you look carefully at Figure 43.

2. Next I wetted the sky area with clean water and then mixed a medium tone of grey, using Ultramarine and Burnt Umber, and ran this in with a No. 14 brush. It is an old sable I have had for many years and, having lost a few hairs, it is now about equivalent to a No. 12. The darker cloud areas were on the left and as I came down the paper I lightened the tone with the addition of a little more water and continued the wash over the whole picture with the exception of the cottage, the road and the river.

3. I now wanted to paint in the far mountain in a suitable warm grey. I mixed Ultramarine and Light Red and painted this carefully round the chimneys of the cottage, and when I came near the top of the mountain I quickly wetted a small area with clear water using a different brush, and allowed the grey mountain colour to run upwards to give the necessary effect of cloud coming over the top. The paper was held level for this operation.

4. Then I mixed up a good quantity of light yellow-green with Raw Sienna and Winsor Blue and I covered the whole of the mountain area, the foreground and the land alongside the river with this wash. At the top of the large central mountain I again used clear water and allowed the green to fade out into it. This was not the final treatment of cloud over mountain top for this mountain, as that would come later. While the wash was still damp I fed in a little Burnt Sienna to part of a right-hand mountain and to some of the foreground.

44 Stage 2

Figure 44, Stage 2

5. I wanted next to complete the mountains and trees etc. The big central mountain was first tackled by adding a darker green shadow. I mixed the same two colours, Raw Sienna and Winsor Blue, to a stronger intensity and painted the upper half of the mountain and made the tone stronger still at the very top, allowing the paint to run into a clear water area washed in with a separate brush over the portion of low cloud. Then I continued with a few darker green areas on other parts of the mountains and, as these dried out, I added strong touches indicating rocky outcrops using a smaller brush and a mixture of Burnt Sienna and Winsor Blue.

6. This mixture was also used to paint the field divisions of stone walls and low trees and shrubs and the nearer trees on the foreground slope. And the small trees and shrubs to the left of the road were also painted, varying the mixture from almost pure Raw Sienna, to a darker green. The very dark tree behind the cottage was a mixture of Burnt Umber and Winsor Blue. Some dark wooden fencing was painted in and some light coloured post and rail fencing was scratched out.

7. I now added some very light tones on the cottage roof and the gable wall leaving the right-hand wall white. Other tones were added to the lean-to and the road-retaining wall. I used a mixture of Cobalt, Light Red and Raw Sienna for these preliminary items.

Figure 45, Stage 3

8. Now we could take the picture to the important last stage, which is usually the most enjoyable and where the final strength and accents are given.

First some cloud shadows were required over the fields by the river which had the effect of holding this area together: one narrow one in the distance and a wide one nearer to. I used the same colour mix as the original wash but darker. And the wide shadow in the immediate foreground was also painted over the sloping grass using a darker tone of green. This shadow extended over the road as well and a grey mixture was used for this of Cobalt and Light Red.

While the grass shadow was still damp I dropped in certain darker areas and grass tufts to

62

45 Stage 3

give the necessary texture. When these were almost dry I scratched out a few light grasses with my penknife.

9. The road next received a little attention with some light brown-grey washes, using Burnt Umber and Cobalt, and some darker track marks using the same mixture but a darker tone. The earthy edges of the road were painted in with a small brush using Burnt Umber and a touch of Payne's Grey.

10. The cottage must now have some strong treatment to bring it into sharp focus against the mountain backdrop. It formed the focal point of the whole picture and that is one reason why I made the small tree group behind it such a strong dark colour, so as to show up the white wall catching the sunlight.

I painted a slightly darker tone of warm grey on all surfaces facing me, namely the gable end, chimneys, lean-to and retaining wall. Then came the dark shadows under eaves and projections of all roofs for which I used Cobalt and Burnt Sienna, also under the stone wall coping. The gate was painted using Burnt Umber and Payne's Grey.

The small lean-to shed was built with dark planks on the side nearest me; the door into it was missing and this void was even darker than the planks. I used Burnt Umber and Payne's Grey in two tones for this shed. It was the darkest object in the picture and gave a sharpness to the composition which I felt it needed.

11. A few finishing touches were now required: some stone joints to the road wall, the iron legs of the feeding trough in the foreground and a branch or two to certain trees. The sheep were produced by means of lifting off colour with a small bristle oil painters' brush and then some modelling of legs and heads added. After this I felt the picture was complete.

I chose this particular mountain picture to be done in three stages because it is not too difficult a one for you to consider in detail and perhaps copy. There is the additional interest of the farm cottage which means that the mountain must not have too much variation of subtle tones in its structure, as it has to take its place in the background.

We will next consider two more colour illustrations of mountains where there are many more colours and tone variations in their build-up; they are a little bit more difficult to paint, but they are dramatic and exciting.

Let us look at Figure 46, *Loch Shieldaig and Beinn Alligin*, painted on the west coast of Scotland in November. This is the time of year when the late autumn colours are very exciting indeed and they amply compensate for the rather cold weather and for sitting out painting in a thick overcoat and two sweaters!

One finds this view by travelling along a third-class road from the fishing village of Shieldaig, going north-west along the lochside. You really feel miles from anywhere, not a car or a human being to be seen at this time of year; you are alone with nature. (Actually my wife was with me administering splendid hot cups of coffee at the right moment!)

I decided on Arches paper 300 lb NOT surface and I first drew, in pencil, a few light marks indicating mountain and loch, but not much drawing to the mountain shapes as I did not want any pencil intrusions where clouds came over mountain tops, as this would damage the effect. It is best almost to do without pencil if you can for these sorts of subjects.

I am sure, looking back at illustrations of mountains by Girtin and Turner in Chapter 1, there was very little pencil used in them. If you can paint straight onto the paper with no guidelines, you are achieving true watercolour.

It was late afternoon and the sky had majestic grey clouds floating by leaving pleasing gaps of white cloud and very pale blue. I kept the sky area fairly wet while I floated in grey washes of Burnt Umber and Ultramarine. A little pale Raw Sienna was used at the right-hand side at the horizon and some watery Cobalt in the central upper area. The grey wash was, of course, carried down over the mountains to the water line as usual (a golden rule this). The water of the loch was left white

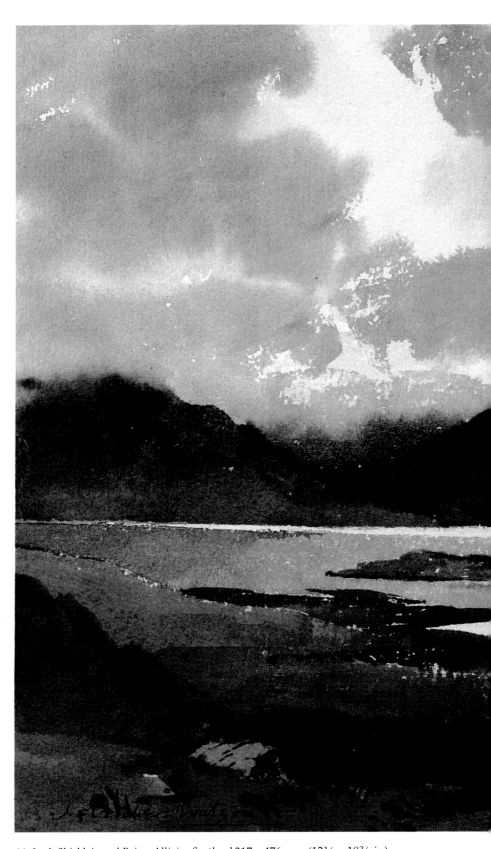

46 *Loch Shieldaig and Beinn Alligin, Scotland* 317 x 476 mm (12½ x 18¾ in)

until the end of the painting.

I next painted the grey-blue distant mountain just showing on the right side and the deep

blue distant mountains to the left of Beinn Alligin, the central big mountain. This deep blue consisted of mostly Ultramarine

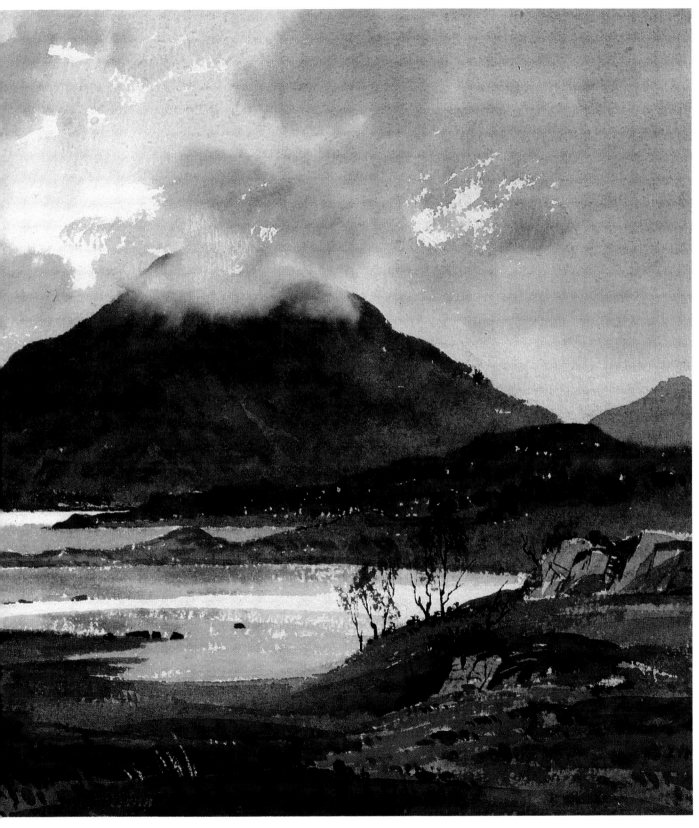

with a touch of Light Red. It is a gorgeous colour which one seems to get more in Scotland than in any other mountainous country in Britain. Low cloud was over those blue mountains and I ran in some water so that the colour ran softly into the cloud.

Now I started on the real meat of the picture, Beinn Alligin itself and the lower range to the left, with three colours – Burnt

Umber, Burnt Sienna and Winsor Blue. It is amazing what colours these Scottish mountains change to in late autumn and winter. It is a mixture of heather, dead grass, dead bracken and bare rock. There are usually large areas of bog, too, which add to the richness and almost blackness of colour. The lower parts of a mountain are usually lighter in tone as they are less steep and catch the light. The mountains tend to be darker at the top, especially if there is a cloud low down near them and they get overshadowed.

Bearing all this in mind I started painting the mountains from the bottom, in this case the water line, upwards. I put on the lighter tones first, a fairly weak Burnt Sienna, and then gradually worked in Burnt Umber and/or Winsor Blue. You need to work fairly quickly so that everything is kept damp and you can go back over areas where you want a little more darkness, or to indicate fissures in rock faces, before they have dried hard and so lost their soft edges.

As I came near the top of Beinn Alligin I dealt with the low cloud coming over the top in the manner already described, using a separate brush with clear water to damp the cloud area and then painting the dark mountain up into it.

Next I painted the right-hand promontories; the far one was extra dark and I used Burnt Umber and Ultramarine.

And now the foreground was painted with various mixes of Raw Sienna, Burnt Sienna, Burnt Umber and Winsor Blue. I was careful to leave the rocks unpainted and deal with them separately using grey-blue mixtures.

The little group of trees with bare branches was now painted, and texture given to the areas of foreground grass.

Finally, the water was painted using different tones of Payne's Grey and a little Burnt Umber at one point indicating slight reflections.

The other picture mentioned with a lot of colour in the mountains, and which was painted in October, is a very fine Lake District view near Crummock Water (Figure 47), with a whole range of well-known mountains in the background to the south-east, the small mountain in the centre being Runnerdale Knotts.

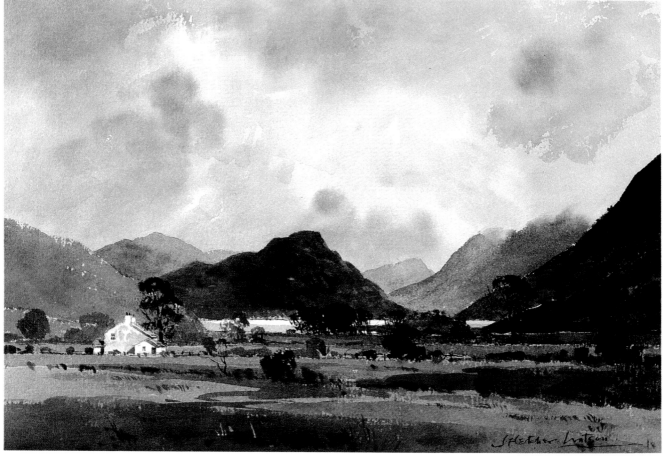

47 *Lakeland vista with Crummock Water* 317 x 476 mm (12½ x 18¾ in)

In this case one is not quite alone with nature, as the little white house gives a domestic touch, but it is a very nice feature helping the composition and giving scale to the mountains.

Again I made very few pencil guidelines, just the thin line of the lake very foreshortened and the house carefully drawn and only the slightest indication of the mountains.

Arches paper was used once again, and it was a Payne's Grey sky with a little Raw Sienna.

The distant grey mountains were mainly light Ultramarine with some Light Red and the nearer ones were a medley of mixtures using Raw Sienna, Burnt Sienna, Burnt Umber and Winsor Blue. The foreground fields were mainly Raw Sienna and Winsor Blue but Burnt Sienna was added for some areas. The basic washes were light in tone so that the dark cloud shadows gave the strong sunlight effect.

I think the eye is carried to the centre of the picture by having the *very dark* small group of trees (Winsor Blue mostly with a small touch of Burnt Umber). The almost white lake is catching the sun and gives a nice contrast with these dark trees.

I was trying to capture the feeling of *infinite depth* which first struck me when I lighted on this view unexpectedly, driving slowly along a narrow road and glimpsing it through the hedge. I hastily found a parking place further on and came striding back to paint it on the spot as quickly as I could with the wonderful light effect. It is a morning view with the sun coming partly into your eyes and partly from the right, hence the very dark mountain slope on the right. The low mountain on the left is, obversely, in sunlight and much lighter in tone. The feeling of recession is obtained by the series of foreground objects: first the rather broken down hedges and bushes, changing to trees as they go away into the middle distance, and finally the mountain outlines in the distance, dark at first and then lighter and lighter.

Constable was a master of depth and light and shade in nature and he referred to it as the *'chiar'oscuro* of nature' in his publication *English Landscape*. Constable was striving to obtain what Wordsworth called 'brief moments caught from fleeting time' and he certainly did achieve all this in his masterly paintings. We must aim for nothing less ourselves, and in mountain landscape subjects we have every opportunity for this.

8 How to paint trees

Many artists ask for advice on this subject and it obviously deserves greater consideration than I have given it in past books.

Trees play such a big part in landscape painting that if you are bad at painting them then you are very severely handicapped. It is essential to really *study* tree formations both in winter and summer and I hope I shall be able to answer some of the many questions that crop up.

Let us first consider how to *use* trees in a landscape. Figure 48 shows a Wiltshire farm with a strong background of trees. The buildings are the main feature of the picture, but they would be nothing without the trees behind them. I am always on the look-out for trees when I am trying to find an architectural subject in the country (and even in the town for that matter). They help a building in many ways, especially summer trees with dark foliage.

You can see how useful the dark tree is at the left-hand end of the large barn: it shows up the cottage chimney beautifully and helps us to see the shape of the different roofs. A fairly dark tree at the other end of the barn where the roof has bright orange-red tiles is also most effective, especially as red and green are complementary colours and always look well together.

The trees to the left of the picture with more open-work to their foliage form an excellent part of the whole composition.

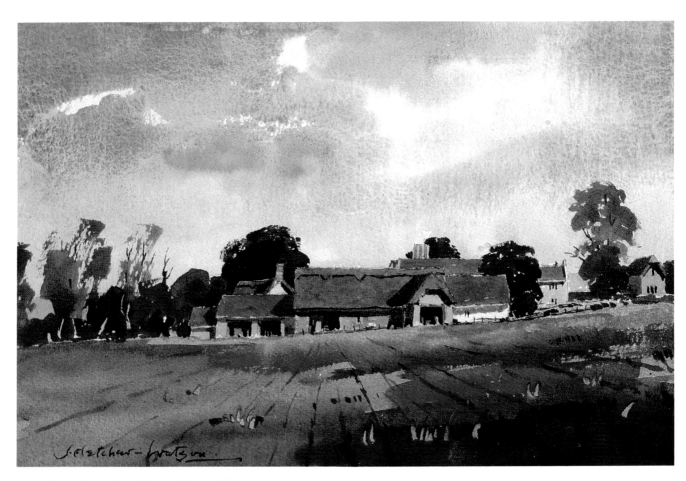

48 *Wiltshire farm* 317 x 476 mm (12½ x 18¾ in)

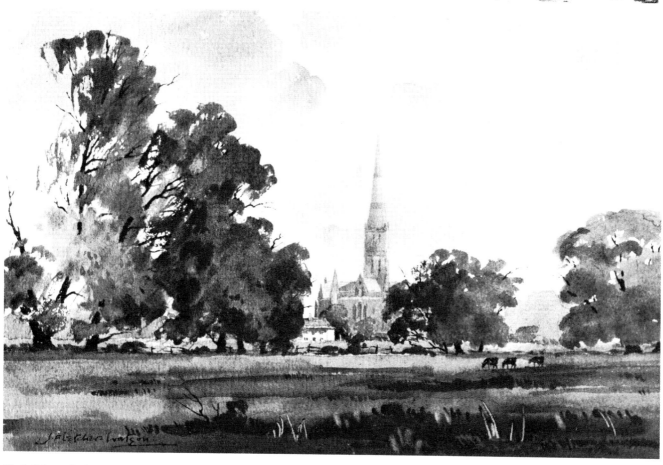

49 *Salisbury Cathedral from the west* 317 x 476 mm (12½ x 18¾ in)

Looking at Figure 49, *Salisbury Cathedral from the west*, we have a picture with almost equal importance given to trees *and* building. The trees on the left would be an attractive subject on their own without any buildings, but combining them and the trees to the right with such an arresting object as Salisbury spire makes a complementary group and a fascinating subject.

If we now look at Figure 50, *Old ash tree, Windrush*, we see an example of trees being more important than the buildings in a landscape. The old ash with some dead branches is a lovely feature in the foreground and helps to give great recession to this picture. The middle-distance consists of cottages and the church, but even here the trees dominate with the buildings hiding behind them. I will come back to the question of *how* the trees in these two pictures are painted in a moment. I am just showing you how useful and attractive trees are when placed carefully in a composition.

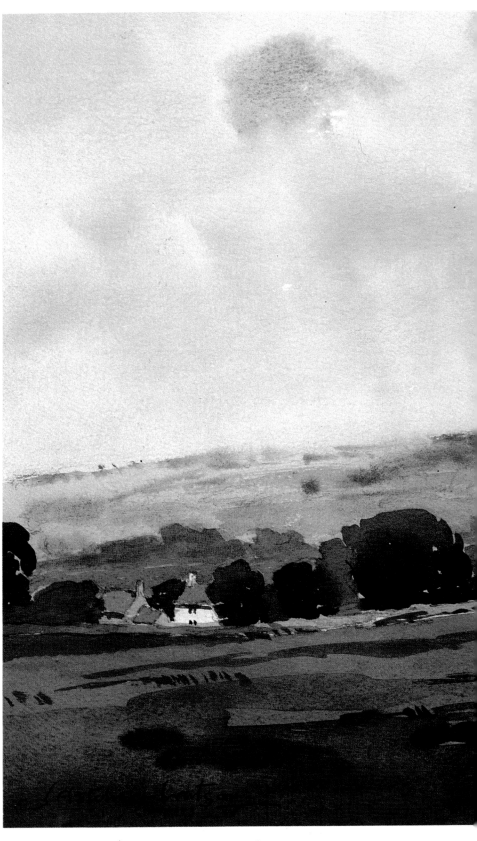

50 *Old ash tree, Windrush* 317 x 476 mm (12½ x 18¾ in)

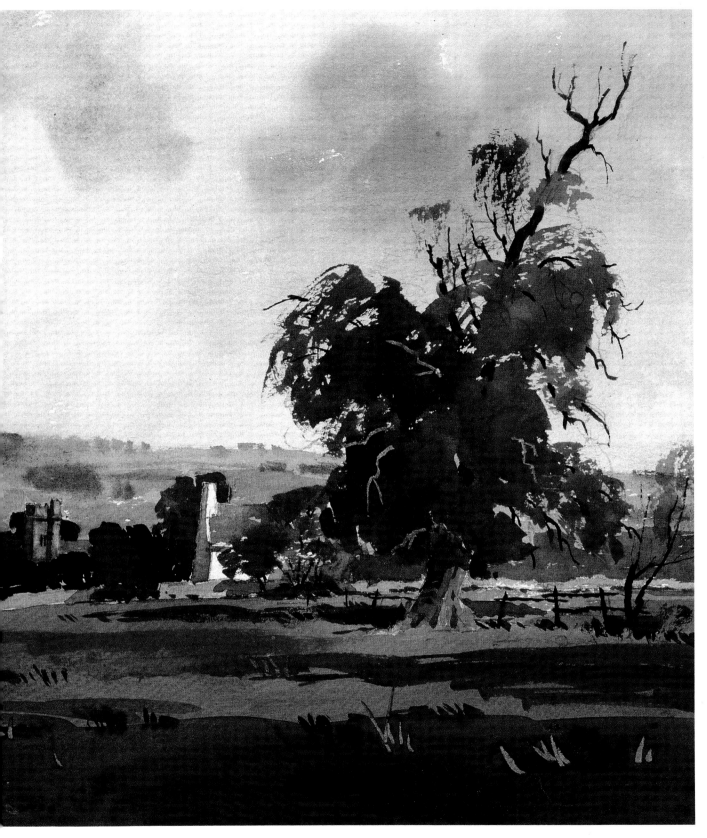

In Figure 51 we have trees dominating with a small cottage in the distance; but there is a big difference, for these are winter trees with no foliage. I am very fond of painting winter trees. You need not paint them in the cold mid-winter; this picture was painted in the spring and it was not too cold. I always think an ivy growth up the trunks of big trees is most attractive and it gives them a whimsical magic which is rather poetical.

Before we go on to look at further pictures, let us consider the technique of painting trees and look at Figure 52, showing some tree studies.

The winter tree on the left could be an ash tree, and I first pencilled in some rough outlines of trunk and upper branches with no attempt at drawing the ivy. Then with about a No. 8 brush I started at the bottom and painted the trunk with Burnt Umber and a touch of Ultramarine. The ivy started about 1 metre (3 ft) above ground, and with the same brush I mixed Winsor Blue and Raw Sienna and painted the broad masses of ivy up to and along the big main branches, and then darkened the green by adding in

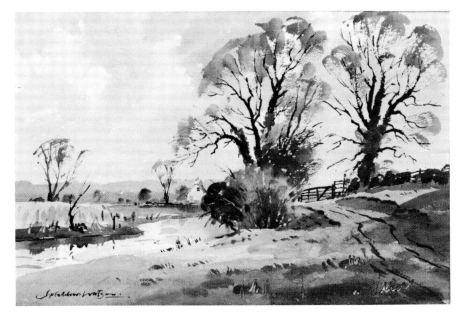

51 *Winter trees, Oxfordshire* 317 x 476 mm (12½ x 18¾ in)

Burnt Sienna and went over some of the ivy again, keeping the edges jagged and rough.

Now with a No. 4 brush and later a No. 1 brush I painted in the thinner branches coming out of the ivy using Burnt Umber and a little Winsor Blue. I was careful to make the branches taper to a very thin line as they went upwards or outwards.

The next stage was to use a larger brush again, about No. 8 or No. 6 according to how big the tree is on the paper, and mix a

grey-brown colour with Burnt Umber and Ultramarine. This must be a really stiff mixture without too much water. I then used the 'dragged brush' technique and, holding the brush sideways, I dragged or stroked it downwards from a point a little above the ends of the twigs, to meet the branches. This indicated a mass of twigs which one does not want to paint individually. If you look again at Figure 51 you will see several winter trees painted in this way.

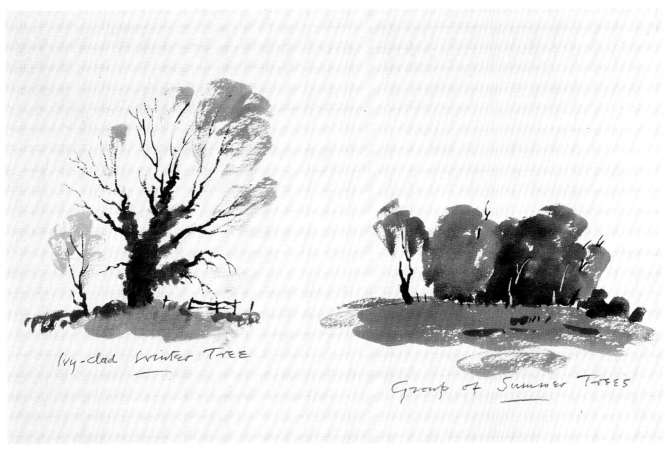

52 Tree studies

The example on the right of Figure 52 is a group of late summer trees with a touch of autumn in the right-hand yellowish tree. Try painting this type of simple clump of trees on a piece of rough paper. A few light pencil marks will indicate the outline and you can then mix up suitable colours, Raw Sienna and Winsor Blue to start with, and use a fully loaded No. 8

brush and boldy slosh on the paint in a broad sweep to indicate the middle left-hand tree. While this is still wet, quickly mix a darker green with Burnt Sienna and Winsor Blue and dash this into the right of it and let it merge slightly. Again, mix some almost pure Raw Sienna nice and strong and stroke this onto the paper to the right. Leave a few gaps of sky at the top if you can. Add a few extra dark touches at the bottoms of the trees.

Now, as the paintwork is nearly dry, scrape in a few thin trunks or branches with your penknife. Also add a dark branch

or two high up in the trees using a small brush (almost any dark colour will do).

The half-bare tree at the left-hand end is put in with the trunk first in dark brown, followed by a quick indication of thin foliage with a stroke or two downwards.

The general effect is simple and unfussy and would fit well into any landscape. Keep practising this until you have mastered it. Pure watercolour painting has got to be bold and free, not fussy and niggly.

Look now at Figure 49 again and observe how freely the left-hand group of trees is painted using this method. Look again also at Figure 50 and see how the foreground ash tree is painted with a series of sweeps of a brush loaded with colour. Some of the branches are scraped out with the penknife, but wait for the paint to become 'tacky' before scraping.

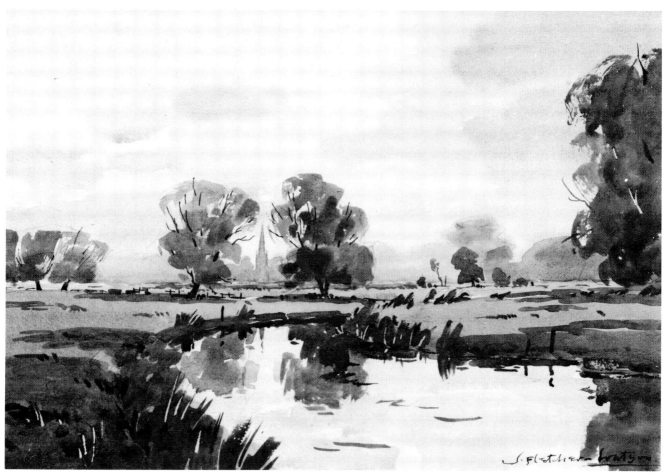

53 *Burford church and the Windrush* 317 x 476 mm (12½ x 18¾ in)

Trees combine with water very
well in a landscape and give
intriguing reflections. Figure 53
shows Burford church framed
between two trees on the river
with pleasing tree reflections.
But my next chapter deals with
reflections. This is really just to
show how happily trees combine
with water.

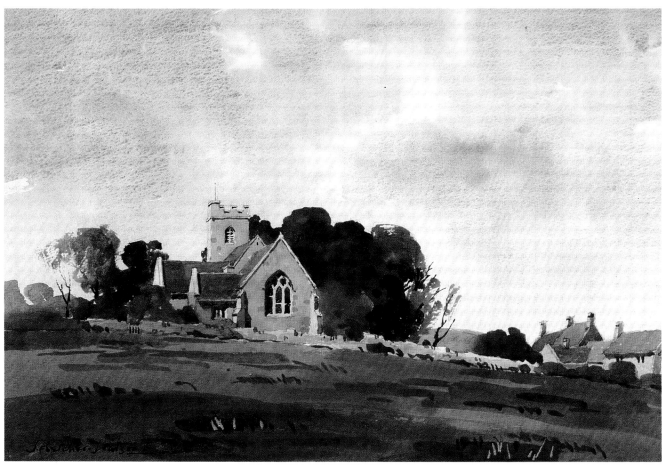

54 *Cotswold church with trees* 317 x 476 mm (12½ x 18¾ in)

Figure 54, *Cotswold church with trees*, is a good example of trees combining with architecture. You can find many country churches in Britain with beautiful tree groups round them, as in early days people seemed to make a habit of planting trees close to the village church. Very old yew trees are often to be found in the churchyard.

You can see what a lovely colour scheme can be obtained with mellow stonework and roofs and rich summer green trees with dark shadowy depths.

Another interesting, and perhaps daunting, subject is seen in Figure 55 – *A Welsh footbridge in a beech wood*. The time was early spring when the pale green leaves were just out and gave a lovely fairy-like mystery to the scene.

My method was to draw in the bridge and tree trunks lightly with a B pencil and then paint the sky, leaving white areas for the green foliage. Then I painted the bridge and next the green leaf areas so that I could paint the trunks and branches *last*. Finally I added the mossy banks and rocks and fast-moving water. The secret of painting such a subject is to think carefully before you start about how you are going to do it in technical terms. It is essential to have a clear *system*.

I would finally like to refer again to some compositions with *buildings* and *trees*, considering not only how to *paint* them but how to *place* them in a picture.

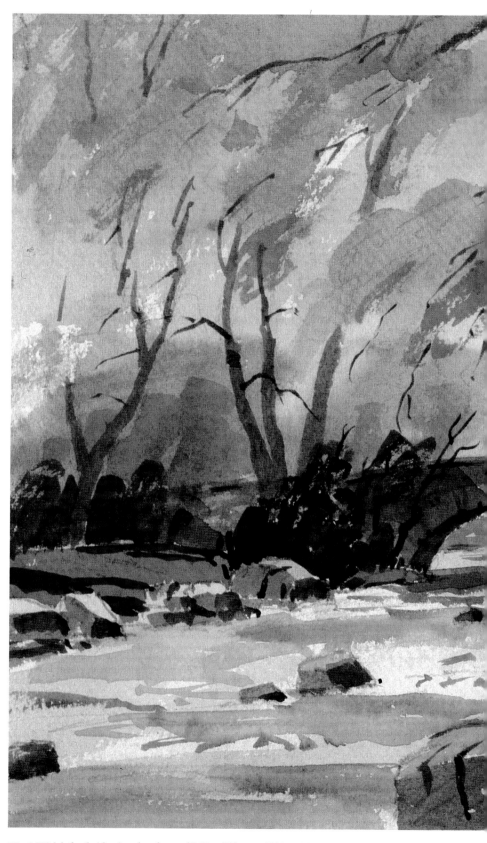

55 *A Welsh footbridge in a beech wood* 241 x 359 mm (9½ x 14 in)

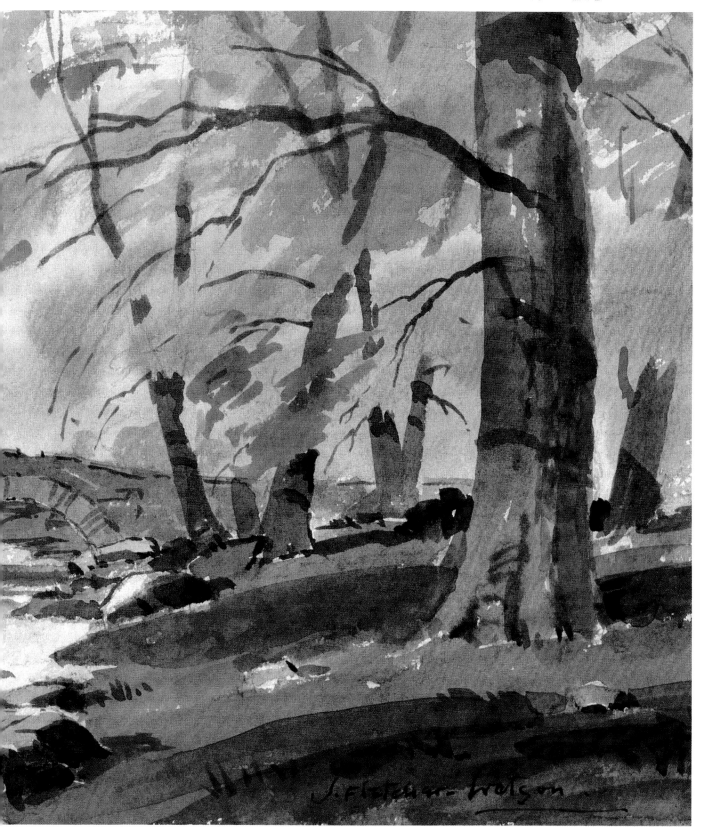

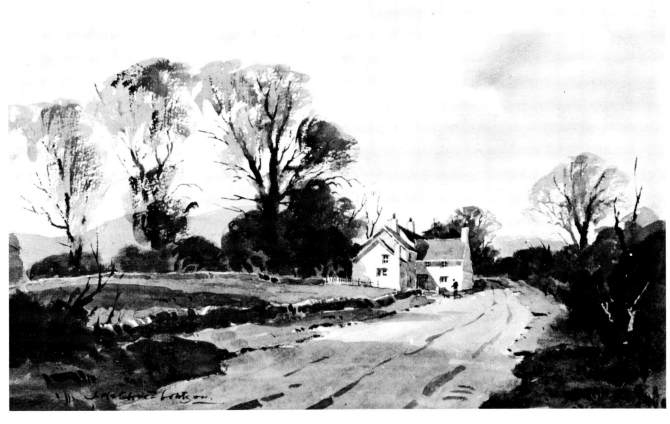

56 *Farmhouse at Dacre, Cumbria* 317 x 476 mm (12½ x 18¾ in)

Looking first at the *Farmhouse at Dacre, Cumbria* (Figure 56), we have three tall ash trees on the left, counter-balanced by the farmhouse and the sweep of the road. Fortunately there was another more distant tree on the right which I adjusted in position so that it prevented there being too empty a space there. The time of year was October so the trees were only just beginning to loose their leaves.

Figure 57 shows Windrush mill with shrubs and a large ash tree in front of the buildings. The composition is interesting with the big tree going out of the picture at the top, thus preventing the feeling of everything slipping away to the right too much.

Finally we have an unusual composition, *Salisbury Cathedral from the south* (Figure 58), showing the great church rising out of the trees. This was painted in August and the trees play a most important part, with cloud shadows falling across them giving changing tones of dark and light foliage. Note the open work in the tree foliage on the left where dry brushwork has been used, and a dead tree with bare branches. Note also the right foreground trees which have leaf texture indicated with a small brush. Generally the trees are given a broad treatment of bold washes and very little attempt at detail, which at this distance would be quite unsuitable.

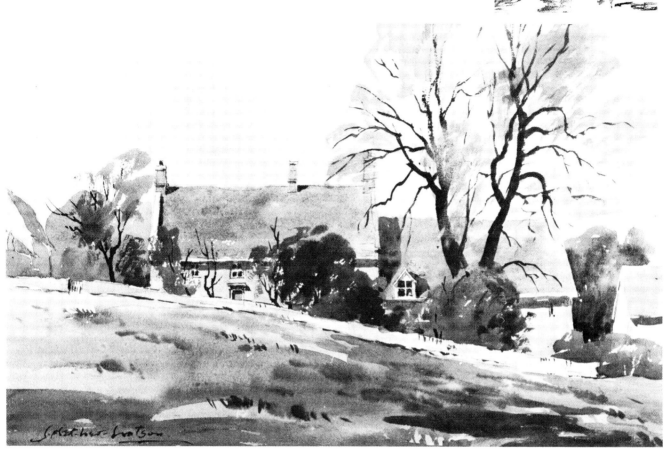

57 *Windrush mill* 317 x 476 mm (12½ x 18¾ in)

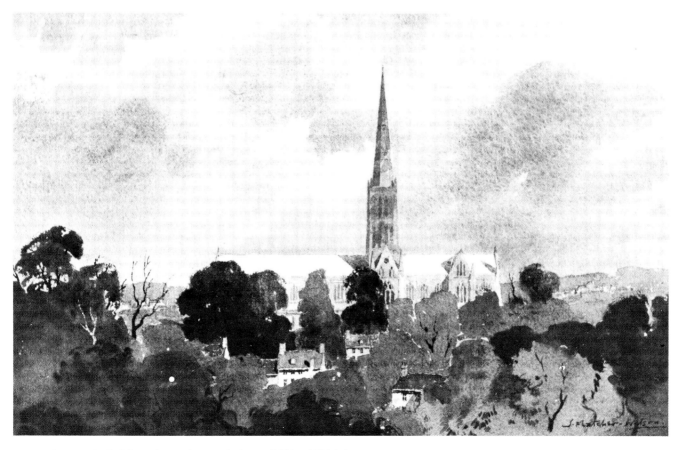

58 *Salisbury Cathedral from the south* 317 x 476 mm (12½ x 18¾ in)

9 How to paint water

Water has always held a great attraction for the painter, but not only the painter: people, especially children, always love a river or lake or the sea. It is no wonder, therefore, that a lot of people ask how actually to paint water.

It is a lovely subject to learn about and I am sure I can pass on a few ideas to my fellow painters without much difficulty.

Water is usually made to look like water because of the reflections of objects in it. This applies mainly to still or slow-moving water. Fast-moving water or sea water is different as we get roughness and waves and not so much reflection.

I will start with slow-moving water, and if you look at Figure 59 you will see a small river called Sherborne brook in Gloucestershire, showing some lovely tree and sky reflections on a summer's day. You can get to this secluded little spot only by walking across several fields and you really feel you are miles from anywhere, alone with the herons which frequent the spot and hearing the cry of an occasional coot.

When painting a picture like this I usually leave the water till *last*. You want to get all the features in before painting their reflections. So I painted sky, distant woods, the far field and river banks and finally the large tree, the footbridge and the large shrub on the far bank. This bush was the darkest item in the picture.

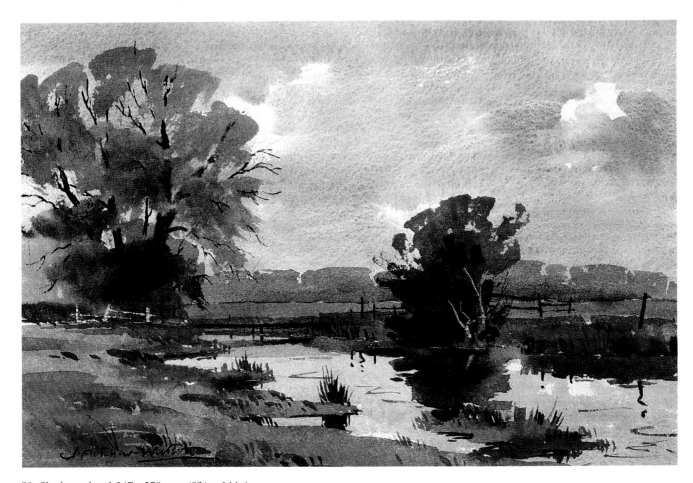

59 *Sherborne brook* 247 x 359 mm (9¾ x 14 in)

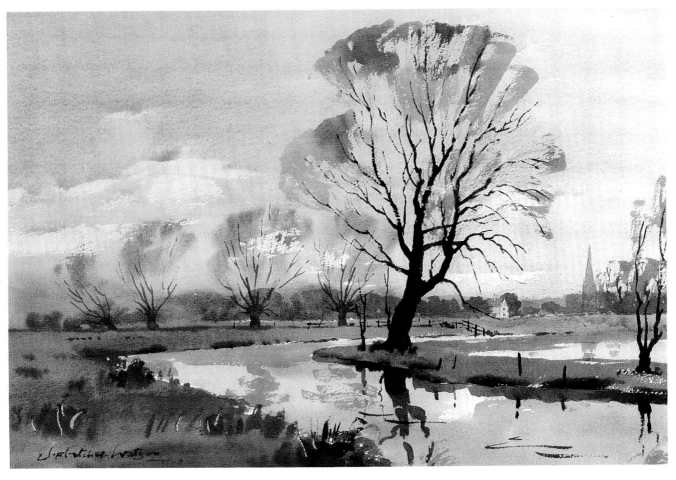

60 *Windrush river with flood water* 317 x 476 mm (12½ x 18¾ in)

Now for the river, which up till now had been left white. I was using Bockingford which is an almost white paper. I first painted the blue sky reflection in the water leaving a few patches of white cloud reflecting. As this dried off I painted in the light grey reflection of the far wood (at the farthest point of the river). Then I tackled the far bank reflection using Payne's Grey with a little Raw Sienna to give a rather *darker* green than the actual bank colour. And before this could dry I used the same colour for the large bush reflection so that it merged with the bank reflection.

The dark green reflections of reeds in the foreground were next touched in and also the narrow reflection of the wooden bridge.

It only remained to draw in with a small brush the several sharp reflections of the vertical wooden posts, and a few marks in the water indicating ripples made by the slight movement of the water.

Incidentally, I used my penknife twice in this picture: once for the narrow trunks of the bush, and again for wood fencing below the large tree.

Another slow-moving water picture, painted in the middle of winter, is shown in Figure 60 – *Windrush river with flood water*.

I wore my thick overcoat and was standing at my easel so that I could stamp my feet and keep warm during the painting! I think the picture has got a cold look about it, but it was such a lovely subject that I could not risk missing it by waiting for a warmer day only to find the flood water had gone.

Water has a way of levelling up tones and the *darks* are inclined to be a little *lighter* and the *lights* a little *darker*. Hence my sky colour in the water is a little bit darker in tone than the actual sky, and the dark tree trunk is a little lighter in the water. It is not an infallible guide but a good one to remember.

The procedure for painting was much the same as for the last picture, leaving the water as the last item to be carried out. The flood water on the right was not pencilled in at all, just quick strokes of the brush with green paint leaving the water edge showing as required.

I took three-quarters of an hour painting on the spot and another 20 minutes finishing in the studio where I could warm up.

It is interesting to note how mountains reflect in water. Looking at Figure 61, we see a mountain called Fleetwith Pike reflected in a stream near Buttermere, and if you want to be sure you are right about the depth of the mountain reflection in the water, you must measure it from its base away across the field to its top in the water. You do *not* measure it from the water's edge: this would make its depth in the water much too great.

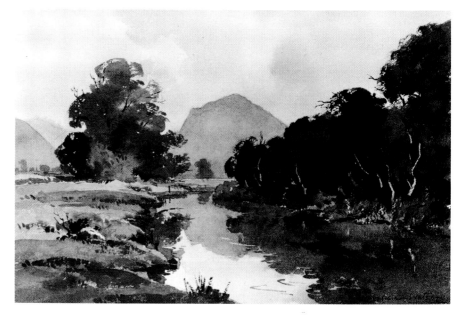

61 *Stream near Buttermere* 317 x 476 mm (12½ x 18¾ in)

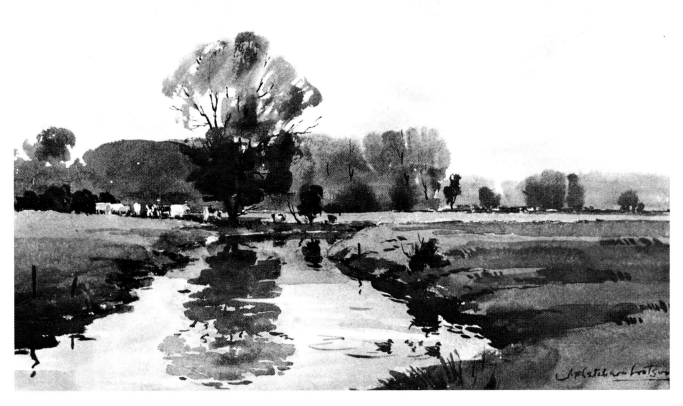

62 *A bend in the River Windrush* 317 x 476 mm (12½ x 18¾ in)

Now look at Figure 62, *A bend in the River Windrush*. Here we have another example of *depth* of reflections. The background woods should have their height measured from their *base* at the far side of the field, then from *that* point you can measure their height into the water. Similarly measure the big tree reflection from *its* base near the bank.

Remember when painting reflections in water to *open up* the reflection at the edges so as to indicate water movement.

In this picture there is a family of ducks at the right-hand bottom corner which is always a fun thing to have. But remember to memorise their correct size before they move off.

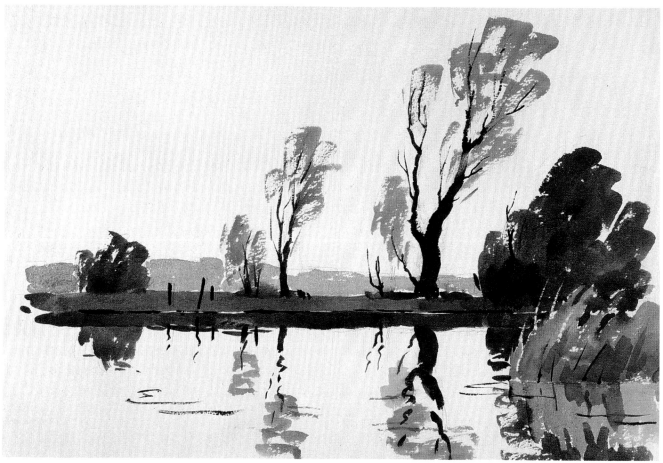

63 Reflection study

At this point I would like to suggest how you can try out your skill at reflections on a sheet of white paper. Look at the reflection study in Figure 63. This is the way to learn how to do reflections – paint little trial bits and pieces on any old piece of watercolour paper when it doesn't matter if you make a mistake. You will really learn a lot by doing this.

For this study I first drew a line or two in pencil indicating a river bank and a line of woods in the background and the trees on the bank.

Then with Ultramarine and Light Red I lightly swept in the far woods, and while this was drying I put in the bank using a strong mix of Raw Sienna and a small amount of Winsor Blue. Finally I put in the reeds on the right, using just Raw Sienna and a touch of Burnt Umber. These

items having dried off, I painted the big tree trunk with Burnt Umber and a little Winsor Blue, and the other small trees and bushes, also the dark low tree group to the right and a dark brown post or two. The light coloured tree foliage was dry brushwork using Raw Sienna and Winsor Blue. I painted a dark brown thin line with a small brush at the base of the bank indicating the waterline.

Now for the exciting part. First I painted the dark bank reflection with Burnt Umber and Winsor Blue, followed quickly by the big trunk reflections using a No. 5 and a No. 2 brush as required, and then the left-hand bush and the dark right-hand trees with a slightly lighter mixture of the same colours, remembering to paint round the reeds carefully. I then added the light colour of the high-level foliage of the trees in

the water, dashing these in with quick brush strokes of the No. 8 brush.

Finally the reed reflections were washed in using a blue-grey mixture of Ultramarine and Burnt Umber and a few ripple marks in the water with a small brush.

Only five colours were necessary for this exercise – Raw Sienna, Burnt Umber, Light Red, French Ultramarine and Winsor Blue.

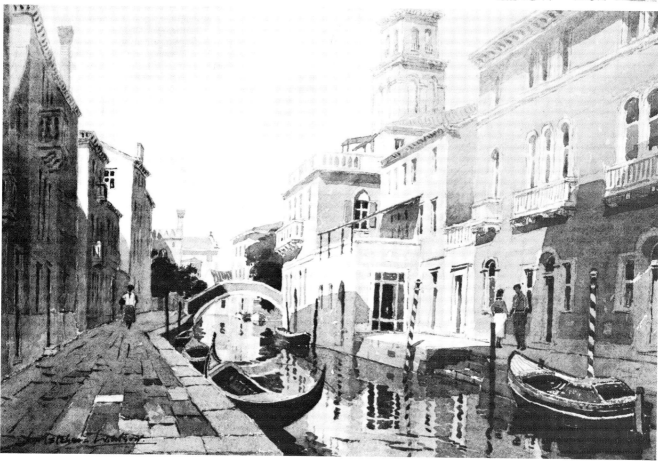

64 *Rio di San Barnaba, Venice* 317 x 476 mm (12½ x 18¾ in)

We have not yet considered water with buildings and what better examples of this do we find than in Venice. Let us look at *Rio di San Barnaba, Venice* (Figure 64). Owing to the narrowness of the canal and the height of the houses, there is no sky reflecting in the water in this view, but the buildings were attractive colours of yellows and reds and this gave a great sparkle of interest to the water.

The technique here is to paint the whole picture before attempting the water, and to paint this last, as in previous cases. Any shadows falling on buildings in the sun, cast from buildings the other side of the canal, must be faithfully recorded in the water as well as everything else. The reflection of the brick and stone bridge with a dark tree behind was a useful and pleasing feature to show reflected in the water.

With slightly moving water you must be careful to make all vertical lines have wobbles and kinks in them.

Jumping on for a moment to Figure 83, you will see another Venice picture which does have sky reflecting as well as buildings and boats.

It sometimes pays to draw a few pencil guidelines in the water of building reflections, which can get a bit complicated, and once you get windows and doors in the wrong place you have missed your chance of getting a good reflection picture.

We have not yet had an example of really rough water, and I now show a fast-flowing Scottish river in Figure 65 – *The Ewe river at Poolewe*. This was painted in the middle of November when the colours are good in Scotland. It is a lovely subject, and I always recommend this western area of Scotland to all those in search of irresistible subjects.

Rough water creates foam and only reflects the sky. My sky here was painted with Payne's Grey and some Raw Sienna, so the water was painted various tones of slightly darker Payne's Grey and plenty of rocky areas with white foam, leaving the natural colour of the paper.

The best way is to start painting the water at the farthest away point up-stream and gradually work downwards, leaving slightly larger white areas as you go. The brush to use is about a No. 5 and is moved sideways a lot of the time with a fairly stiff mixture of paint, it being mostly dragged-brush painting. But at the near end of the river quite a lot of water was used in the mixture, in other words a fairly wet wash.

The various rocks had been pencilled in and were painted at the end.

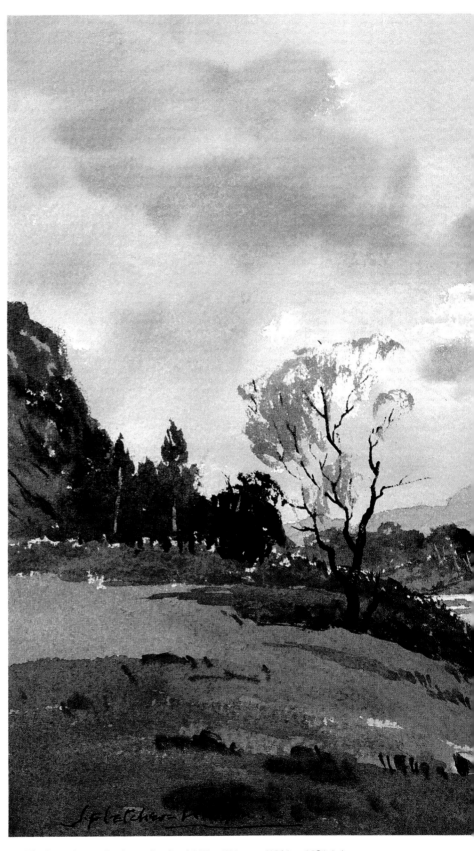

65 *The Ewe river at Poolewe, Scotland* 317 x 476 mm (12½ x 18¾ in)

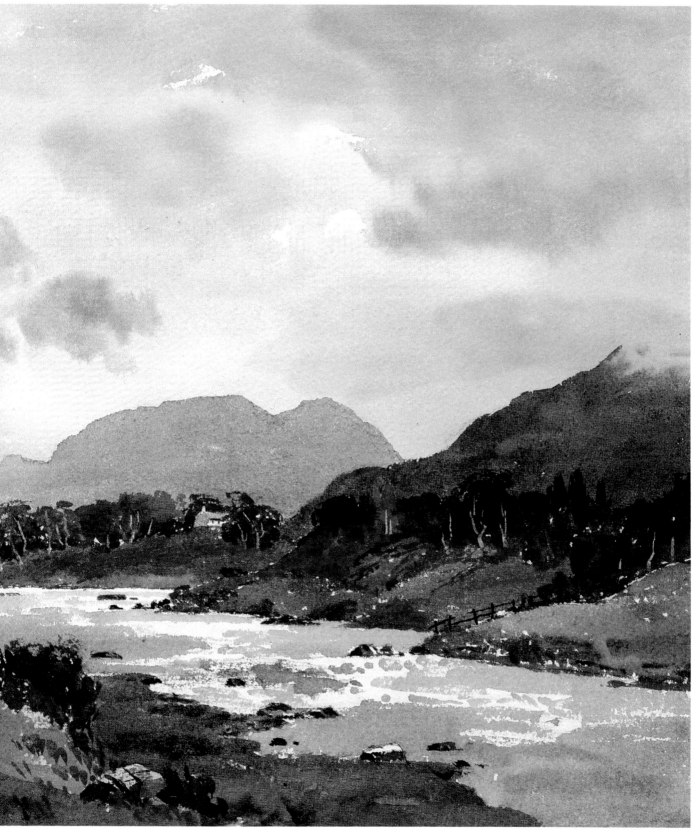

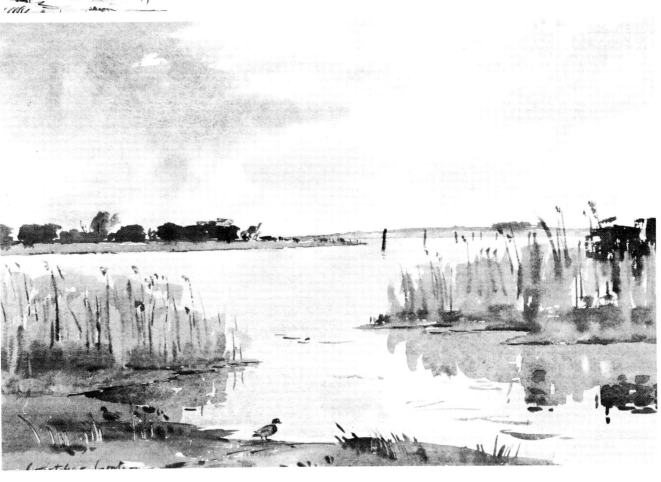

66 *Hickling broad, Norfolk* 317 x 476 mm (12½ x 18¾ in)

A further example of fairly still water is a Norfolk broad, and Hickling broad is shown in Figure 66. This wide expanse of water is a most attractive subject to paint, and on an average day there is a slight breeze on the broads and you do not get a reflection of distant features owing to a little ruffling of the water surface. You do, however, get the reflections of close-up objects such as blocks of reeds, which are a very typical feature. You will notice that there is some detail given to the actual reeds but in the water the reflection should be kept completely simple.

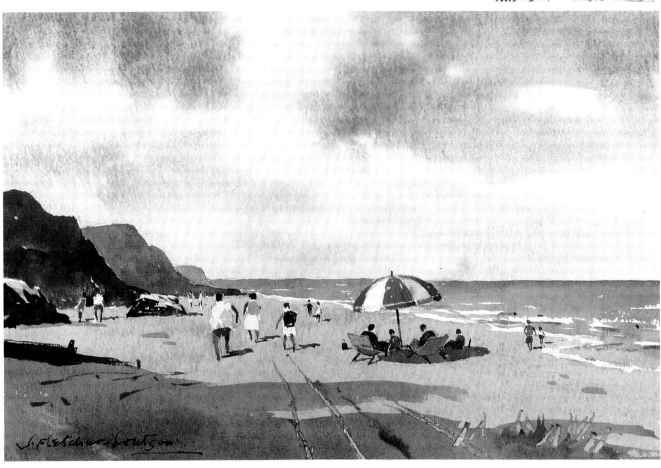

67 *Normandy beach* 241 x 359 mm (9½ x 14 in)

Another picture showing how to paint water is a seascape called *Normandy beach* (Figure 67). I did not paint the water quite last and I first painted the sky followed by the sandy beach, which was a flat wash of diluted Burnt Umber. Then followed the cliffs and rocks, and at this point I wanted to put in the sea so that the final work should be figures and shadows.

The sea colour is not always the same as the sky by any means, and here it was a slightly greenish-blue, mixing a little Raw Sienna with mostly Payne's Grey. The sky colour was Ultramarine.

The sea wash was put on with a No. 8 brush taking care over the straight horizon, and when I got near the beach I changed to a No.

4 brush and was careful to leave out white thin areas for the foam of the waves. I ran in a little Raw Sienna to make the blue water go green in the shallow edges of the sea where it washed onto the shore. Then I added a few dark touches to emphasise some of the waves.

The sea was thus completed and I could finish the picture by painting in figures and shadows on the sand.

At the beginning of painting I had left a few bits of white on the sand area for a white skirt or shirt and now I could add other colours to these items and add arms, legs and heads, not forgetting to paint the umbrella, which had also been left white.

Seascapes are great fun to do and I hope I have been able to show you that it is not a difficult subject when the sea is not too rough.

And now for a very beautiful still evening on a small Scottish loch, Figure 68 *Loch Dughaill*. This example of totally still water was painted on Arches paper, and having drawn in the mountains and fir trees I also drew in, lightly, the reflections in the water. There was slightly wind-ruffled water at the far end which was catching the sun and which showed up white. This was left the white of the paper. When it came to painting the reflections in the water I systematically painted in the different mountain colours and the dark tree shapes on a slightly dampened paper so that my edges were not too hard. At the end I floated on a very light grey wash over the whole water area of Burnt Umber and Ultramarine to weld everything together and give the water a darker tone than the sky.

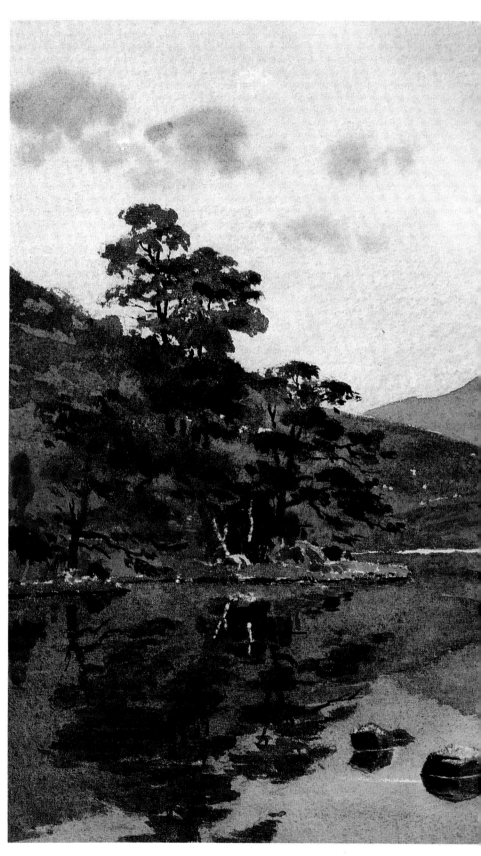

68 *Loch Dughaill* 317 x 476 mm (12½ x 18¾ in)

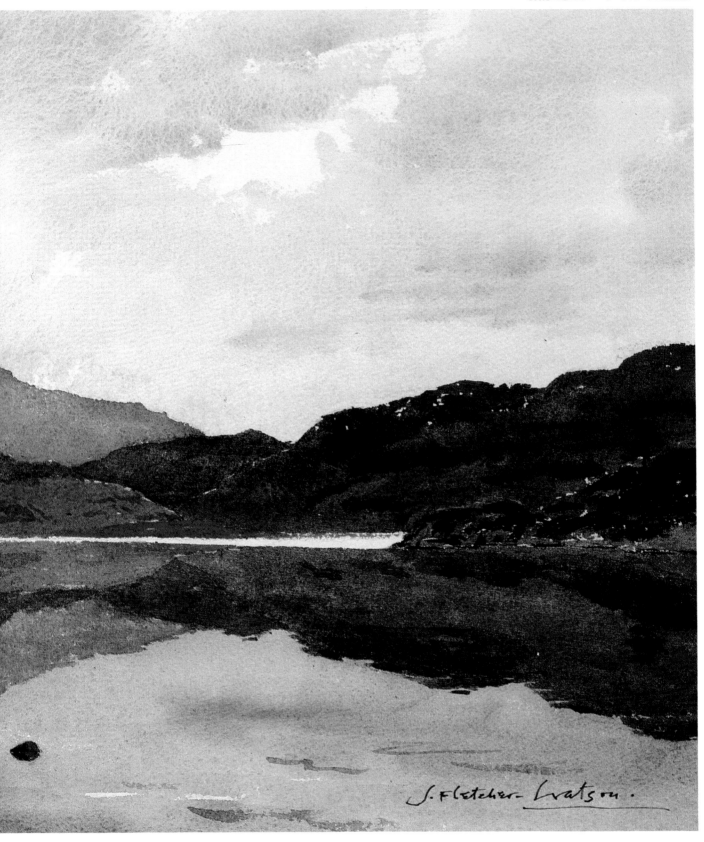

J. Fletcher Watson.

10 How to paint snow

When people talk of snow pictures one is apt to think of Christmas cards and a coach and horses pulling up at a country inn. Some people think a snow scene is a 'cheap' subject not to be undertaken by 'real' artists, but I am afraid I disagree with this. Some very beautiful landscapes have been painted of snow subjects and I myself love doing them.

A snow scene is not as difficult as some people think, in fact it is really quite easy. As long as you learn to let the white paper do half the job for you, and keep your picture thoroughly simple with clear wet washes and direct unfussy brushwork, you will paint a good snow picture.

Look now at *Windrush mill under snow* (Figure 69). This is a splendid subject and I have painted it at many different times of the year, but it is especially appealing in the snow.

Snow is always whiter than the sky and even more so with a cloudy sky. Note also that water is apt to look dark when adjacent to snow. The thing to remember is to paint the snow *last*.

I started this picture by drawing on Bockingford with a B pencil; it was important to work out the composition carefully so as to get the most advantageous arrangement and balance. The river took a bend to the left as it approached the mill and I wanted it to cover about two-thirds of the left part of the picture, leaving one-third of snow to the right; I also wanted a

69 *Windrush mill under snow* 317 x 476 mm (12½ x 18¾ in)

little of the foreground bank to show in the picture. This would allow the building to occupy just the correct position to the right of centre with the heavy dark group of trees running out of the picture to the right. The tall tree behind the mill was invaluable in showing up the white snow on the roof. In choosing your snow subject you want to give an eye to what features will show up the snow well with good contrast.

The order of painting this picture was as follows:

1. Sky first, using Payne's Grey and some watered down Ultramarine for the blue patch to the left. This was placed there on purpose to give a nice balance.

(I was painting this on the spot wearing appropriate clothing.)

2. Distant trees in grey-blue to left of mill using Cobalt and Light Red.

3. Stone wall faces of mill and other buildings using Cobalt, Light Red and Raw Sienna, varying the tone in different places. The stone buttress received dragged brushwork so as to leave some white where snow was clinging to the sloping wall. I was careful to leave white ledges on the chimneys where snow was sitting on mouldings.

4. The tall tree behind the mill (this is one tree although it looks like two) was painted next and all the other trees and shrubs, using all the techniques of tree painting described in Chapter 8. I used various mixes of Raw Sienna, Burnt Sienna, Burnt Umber and Winsor Blue and the penknife came in useful for several small trunks and branches in various places.

5. Shadows on buildings were painted under roof eaves and on left sides of chimneys and gable ends etc. The colour was simply a darker tone of the original wall colour.

6. Windows were painted in a dark colour with Burnt Umber and Ultramarine, also the dark door of the lean-to shed and the dark opening at water level letting the river run through the mill to the mill wheel inside.

7. I could now paint the water, which I had had to delay until now so as to know what colours of buildings, etc. were going to reflect in it.

First I painted the stone wall relections a slightly darker tone than the actual walls were and then the sky reflection with Payne's Grey, and then the dark brown shrubs a little lighter than they themselves were, and of course various eaves' shadows and window and door reflections. I had pencilled in a few guidelines for reflections and I made everything wobble and wave a little to indicate the movement of the water. When all these reflection items were dry I floated on a wash of light Payne's Grey with a touch of Raw Sienna mixed in, all over the water to tone it down a little, and was careful to leave the thin bent trunk in the left foreground dead white at this stage as it was snow-covered on its upper side.

The picture was now getting well advanced and the areas of snow were showing up well the vivid white of the paper.

8. Now for dealing with the *snow* which was virtually the last item to be painted. First I put in the roof shadows of dormer window and house roof shadow onto the snow-covered lower roof of the mill, also the shadow on the small shed roof on the right, cast from trees. A few subtle touches of shadows were required at

eaves' level where the snow showed thick on the roofs. Almost last were added the shadows from clouds on the left and right areas of snow covered river banks and foreground field. I used various mixes of Cobalt and Light Red and Ultramarine and Indian Red for these blue-grey shadows. It is most important to put on these wet washes with simple brush strokes quickly applied so that in some places the white paper breathes through.

9. Final touches were a few dark brown posts in various places, the bent thin tree trunk at the left foreground which required dark edges to the underside, the yellow grass peeping through in the right foreground and the moor-hen striding across the snow.

When I had reached the end of item No. 7 I retreated home to the studio (this mill is only a few hundred yards from where I live), and completed the work to the snow and the finishing touches in warmth and comfort.

If you can manage to face the cold and paint a snow scene out of doors you will learn many valuable lessons about contrasts in snow and how strongly you can afford to paint winter trees and so on. But I often paint a snow scene completely in the studio from a pencil drawing made on the spot.

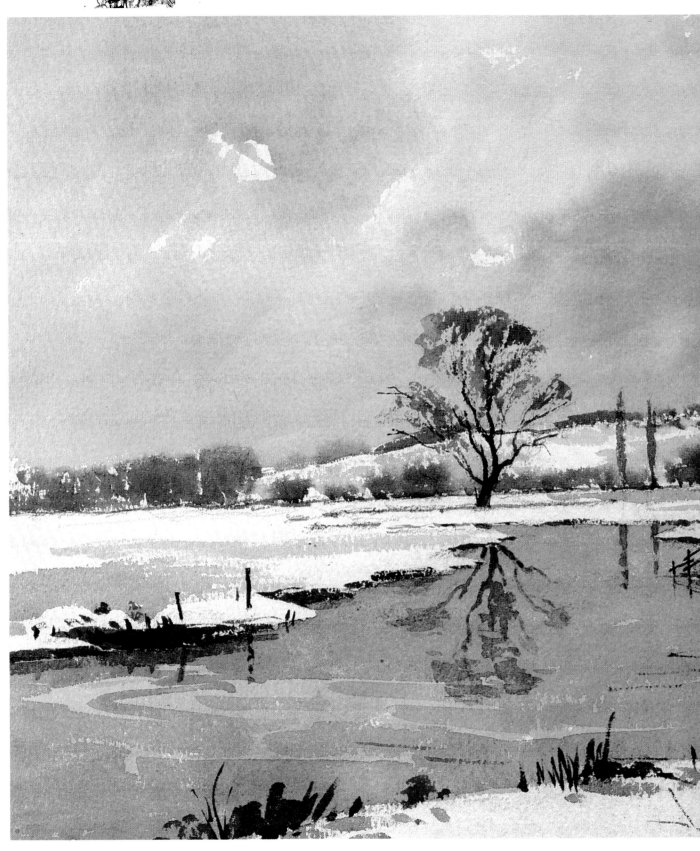

70 *Snow at the River Windrush* 317 x 476 mm (12½ x 18¾ in)

Figure 70, *Snow at the River Windrush*, is an open landscape where distances can be seen. After painting the sky I followed that by painting the water a slightly darker blue-grey – and the picture was almost half-finished. The white paper does it all for you! It was simply a matter of painting in all the different browns of tree groups and hedges and earthy bits of river bank and the large tree that was reflecting well in the water. Then I could paint the blue-grey shadows on the various fields – they were quite a strong Ultramarine and Light Red mixture in the foreground – and finally a post or two, adding reflections as necessary.

Another example of snow with buildings is shown in Figure 71, *A Cotswold farm*. Here we have a lovely old farmhouse, large barn and outbuildings making a delightful group. The dark trees are a very important contributory factor. Dark winter trees are excellent against snow-clad steep roofs and Cotswold grey walls.

Dark shadows under overhanging eaves and on walls combine with cloud shadows in the foreground to give a nice gleam of sunlight to the scene. The large tree with ivy-clad trunk is a good feature in a winter landscape, and now that you know how to paint these (see Figure 52) you ought to be able to paint a lovely snow picture!

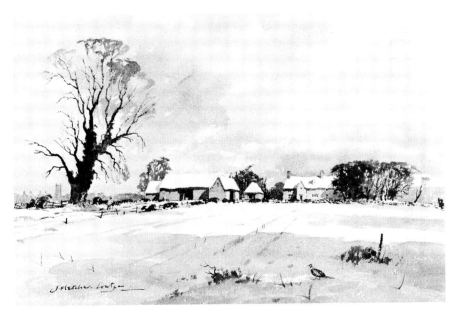

71 *A Cotswold farm* 317 x 476 mm (12½ x 18¾ in)

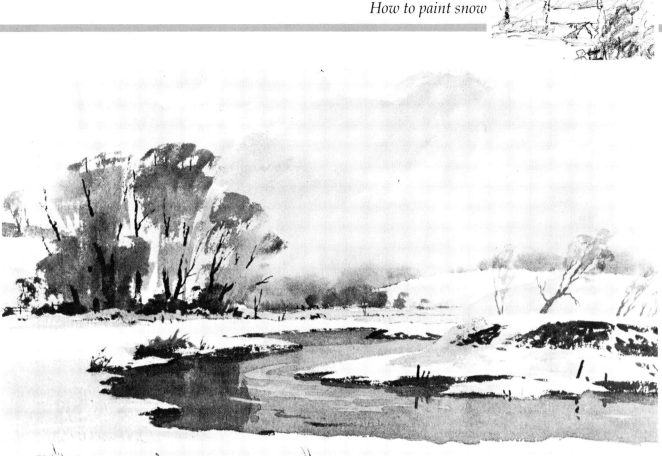

72 *River in winter* 317 x 476 mm (12½ x 18¾ in)

Figure 72, *River in winter*, was a lovely simple snow scene to paint. I was able to put this whole statement down quickly and so paint it all on the spot. It took just over an hour to paint. The only snag of painting in the snow is that watercolour does not dry quickly, but as half the paper remains untouched white snow, it does not really matter too much.

I put the sky on with a wash that did not have a lot of water with it so it did dry off quite quickly. This was followed by the *distant* trees which you can see were run in while the sky was still *damp* and a nice distant blur was achieved.

The dark copse of trees was fun to do, dashing in the washes first with dragged-brush technique and putting in trunks and branches as this dried off. The river looked extremely dark, which set off the snow beautifully. I used pure Payne's Grey for this. More dragged-brushwork was used for the brown earth on the steep little bank to the right, leaving rough almost vertical places which snow had not covered.

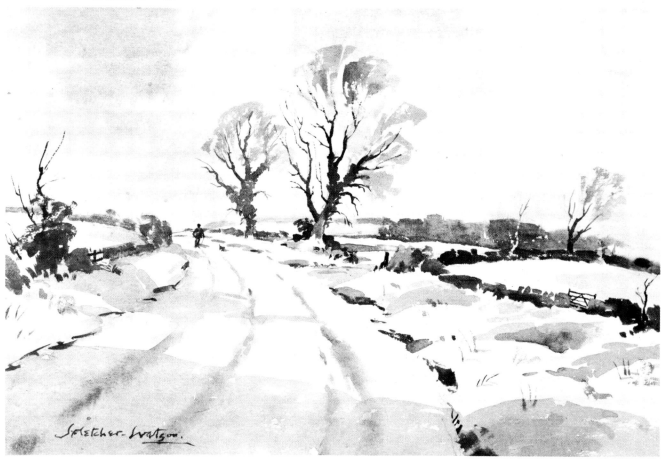

73 *Cotswold by-road in January* 317 x 476 mm (12½ x 18¾ in)

There was a lot of blue sky with the clouds in Figure 73, *Cotswold by-road in January*, and the sunshine was intensely bright. This was achieved by making the stone walls and shrubs and bits of earth at the roadside a little darker than usual. The paint was, in fact, put on extremely thickly and this gave the necessary crispness to the snow. The shadow from the left-hand bush and the foreground cloud shadow had a lot of Ultramarine with the Light Red and a touch of Indian Red and this helped with the general feeling of glaring bright sun.

I painted this on the spot but sitting in the car, so I was comparatively warm.

I hope I have helped you with how to paint snow, and I should emphasise that half the battle is *choosing* a good snow subject.

You must really take trouble about finding a view with dark features in the way of shrubs, woods and individual trees as well as buildings or bits of dark fencing and dark wooden posts. Any old flat snow scene will not do, and if you are lucky enough to have sunshine thrown in, then that is a bonus.

11 How to paint buildings

The subject of buildings covers a very wide field from lonely cottages and farmhouses to villages and busy towns. I have got quite a variety of pictures to show you which deal with a great many of the problems my painter friends ask me about from time to time.

To paint buildings well you should acquire a fair knowledge of *drawing* with a pencil. Draw simple buildings first like barns and small cottages, filling a small sketch book with them. You will soon find you can draw a subject like Windrush mill (Figure 74). This picture was drawn on cartridge paper quite quickly with a 4B pencil using a firm line. Some washes of colour were added afterwards, which brought out the tone values. From this type of drawing you learn how dormer windows and chimneys fit onto sloping roofs and how eaves overhang walls and so on.

74 *Windrush mill* 203 x 279 mm (8 x 11 in)

75 *Broad Chalke, Wiltshire* 317 x 476 mm (12½ x 18¾ in)

From here it is a short step to painting a simple village subject such as Broad Chalke, Wiltshire (Figure 75). Having drawn the picture rather carefully first on Bockingford paper, which is excellent for architectural subjects, I then added some pen work using the Staedtler F which is the fine point. As I have mentioned in Chapter 2, this pen is very suitable with watercolour. I penned in the cottages and dustbins and the foreground wall and a few lines indicating the footpath and road. All the rest is pure watercolour. I think you will agree that this is a nice technique for building subjects, though it is important not to overdo the pen work.

Figure 76, *The Turl, Oxford*, is a slightly more elaborate subject where perspective plays a part and figures are important to give scale and movement, which one wants in a town.

If you make drawings like this of your local town it will help you no end with perspective and I shall say more about this a little later on.

76 *The Turl, Oxford* 254 x 190 mm (10 x 7½ in)

J.F.W.

The Turl - Oxford.
23 Oct 84.

Now let us look at a town watercolour picture. Figure 77 shows Shepherd's Market, London, and this quiet little back-street is beautifully scaled down and a very paintable subject. This small picture, only 140 x 203 mm (5½ x 8 in), was drawn in pencil in skeleton only to start with, leaving out all detail like windows and sun blinds; then it was drawn in more detail with my old fountain pen which has a nib which flows well. I did not use ink but mixed up a dark watercolour with Burnt Umber and Ultramarine and fed this into the nib with a brush. I have learnt to distrust the brown and black ink one gets out of a bottle as I have had a lot of pictures where the ink has faded after ten years.

The vanishing point for perspective guidance is somewhere on the right-hand side of the archway, at eye level. I had this in mind as I drew the slanting lines of the top parapets of houses and window heads and it is a great help to a building picture to have the perspective reasonably correct. You don't have to draw lines with a ruler – that would make a picture look thoroughly boring and lose all feeling of life.

You will note how important shadows are in a building subject. On a sunless day this picture could be extremely dull whereas the strong shadows on this sunny day give real sparkle and punch to it.

Colours used were limited to Raw Sienna, Burnt Sienna, Burnt Umber, Ultramarine and Payne's Grey.

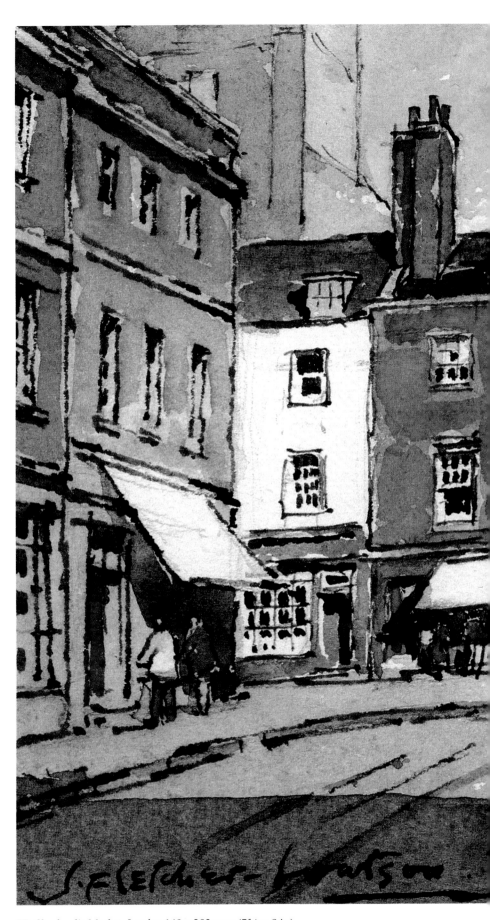

77 *Shepherd's Market, London* 140 x 203 mm (5½ x 8 in)

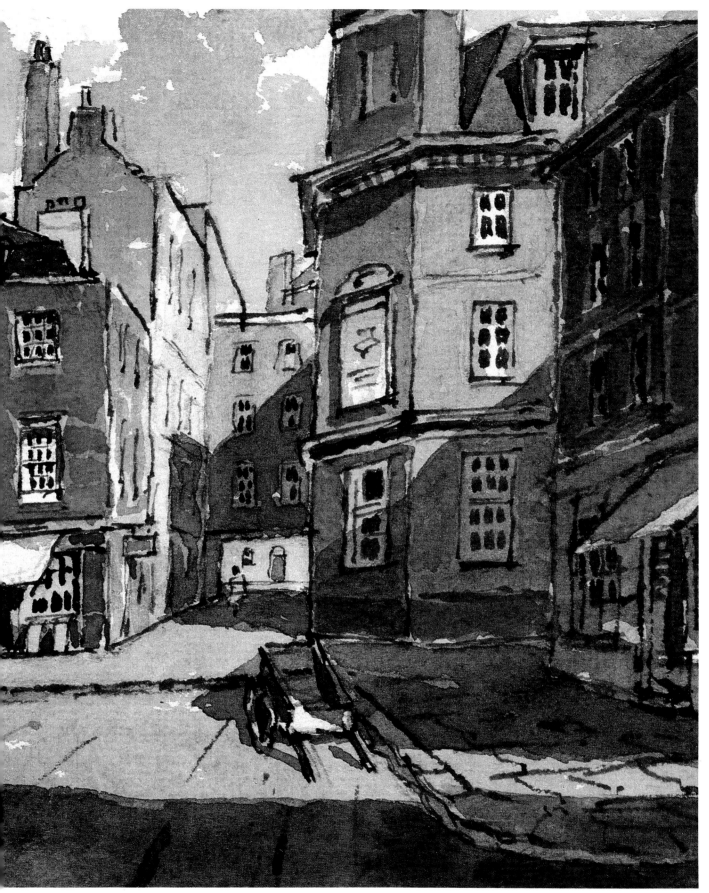

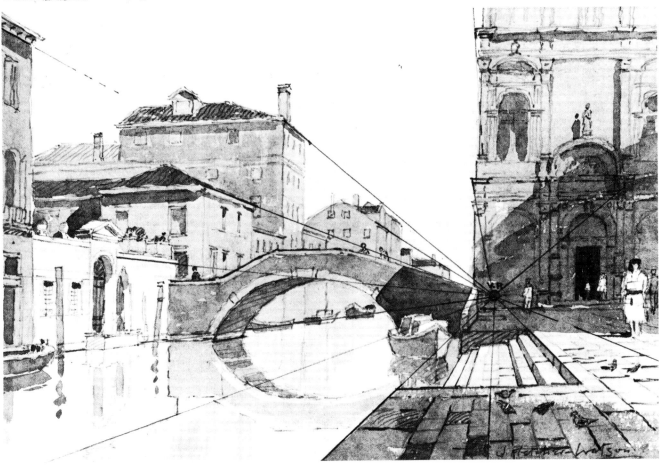

78 Demonstrating perspective on a Venice canal 235 x 359 mm (9¼ x 14 in)

I said I would mention perspective again and in Figure 78 I show a demonstration of perspective on a Venice canal with lines ruled in, for clearness, all converging on the vanishing point just to the right of the bridge. You find a vanishing point by holding up a long pencil or anything straight and tracing theoretically the line of roofs and the side of the canal and so on and see where it is that they all meet. On this picture I have drawn on boldly a few lines to show you how it is done. Once you have fixed this point it is sometimes worth making a small dot on your paper representing the vanishing point and that will be a very useful guide while drawing the buildings in.

(If you require more guidance on perspective you will find a lot of information given in Chapter 6 of my book *Watercolour Painting, Landscapes and Townscapes*.)

79 *Colegate, Norwich* 381 x 686 mm (15 x 27 in)

Turn now to Figure 79, *Colegate, Norwich*. This is quite a large picture measuring 381 x 686 mm (15 x 27 in) and it was painted on Bockingford paper. It is rather a fine composition, almost like a stage set, and this is partly due to the churchyard having its iron railings removed.

It is a good example of firm pencil work used with watercolour; there is no pen and ink work. I drew the buildings with a 2B and sometimes a 3B pencil and if you look closely you can see the pencil work showing through the watercolour.

The old building in the centre has a very steep roof and steep dormer window gables and another large gable facing us. These gables have black painted 'barge boards' and I used the dragged-brush technique for them. The whole design is typically East Anglian and shows the strong Dutch influence that runs through so many Norfolk and Suffolk buildings.

You will notice the quite dark shadows under eaves and overhanging walls and the not-so-dark shadows on the building from the left-hand tree. Note also a cloud shadow on the right-hand building and the strong foreground shadows cast from street houses on this side of the road. All this shadow work was carefully observed and thought out so as to help the composition and give maximum sunlight to the scene. The dark shadow on the east wall of the church plays a vital part in giving emphasis and holding the picture together.

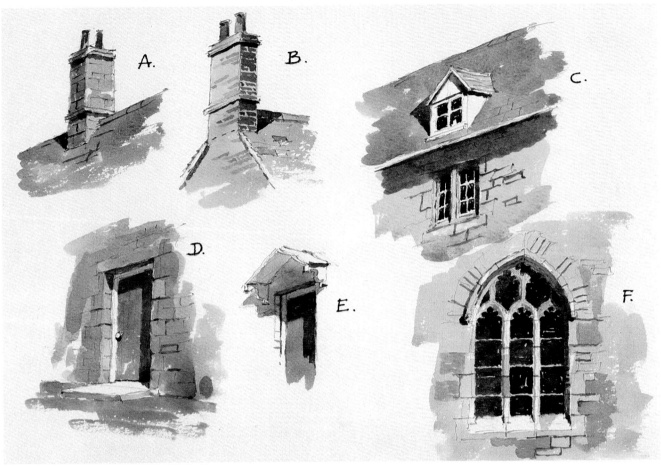

80 Studies of building features

If you will look next at Figure 80 you will see studies of building features. This shows close-up details of some of the items we have been looking at in illustrations shown in this chapter.

A shows a typical chimney stack with two chimney pots. Note the angle of the shadow of the stack on the roof. I would like you to draw this chimney with its stone jointing in your rough sketch book so that you will not forget the method when it comes to putting a chimney on a roof in your next appropriate painting.

B shows another chimney stack, this time at the end of a roof on the gable end. Note the shadow again.

Now in *C* we have a dormer window and a casement window in the wall below. Particularly note the shadow on the roof from the dormer, and the eaves shadow which goes *into* the window recess and gives the window depth. The glazing of the windows is painted with a small brush using Burnt Umber and Ultramarine. Note the stone quoins round the window, i.e. larger stones than for the walling.

D shows an outside door in a stone wall. The important thing is the shadow showing how the door is well recessed into the wall with its white painted door frame. Stone joints drawn in with a thin small brush give perspective and texture to the wall. All these details are so easy but so often neglected. Try painting this door carefully in your sketch book and you will then be able to suggest it in a picture accurately but perhaps a little more roughly.

I show a little wooden porch in *E* of the type often seen over a cottage front door. See if you can draw this – it is a very useful detail to know about.

Finally in *F* we have a typical Gothic east window to a church. This is the Early English style and is more often seen than any other Gothic style.

It is really quite easy to draw and is worthy of a little study. Divide your window first into three with vertical stone mullions up to the 'springing' of the arch. Then make three little pointed arches and put three short mullions over the centre of each arch. Add a few stone joints in both *mullions* and walling. You always get a joint at the springing of the arch; and at the apex there is always a *vertical* joint in Gothic architecture. I would strongly advise you to make a copy of this window. Once painted you will never forget it. You will see an example of it in Figure 54.

I would now like to say more

about buildings seen *collectively*, that is to say a town or city view. Venice is one of my favourite places to paint buildings and there is the added bonus of having water as well. So now refer to Figure 83, *Rio Di S. Anna*.

I am going to describe the painting of this picture in detail for you, stage by stage, as it was not a difficult picture to paint and I think you will be able to learn a lot about the technique required for architecture.

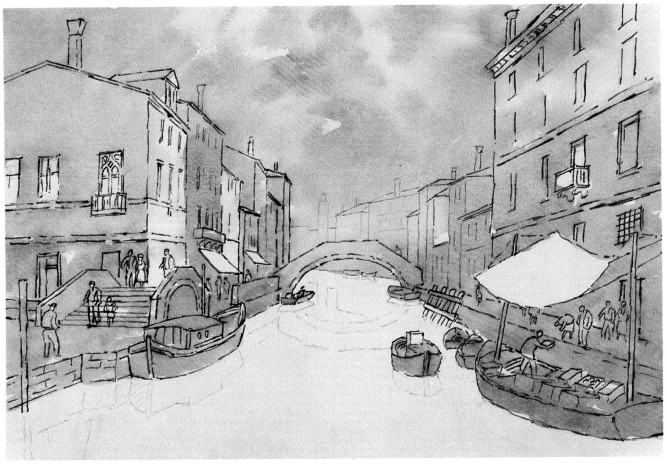

81 *Rio di S. Anna, Venice*, Stage 1, 317 x 476 mm (12½ x 18¾ in)

If we look at Figure 81 we will see Stage 1 of the picture. For a start the composition was easy as I was looking down the canal from a mid position, and the far bridge and distant grey buildings automatically gave the focal point. I was not sitting in a boat, as would appear, but standing at a stone parapet as this canal came to a dead end here.

The position of the sun was on the right so that all the buildings on the right were in shadow. This helped the composition no end. You must always watch out for the lighting on Venice canals and paint your picture at a time of day when the shadows are interesting.

I arranged my viewpoint so that the tall foreground building on the right would partly run out of the picture at the top; this again helped composition and gave an irregular and not too perfectly balanced picture.

1. I was using Bockingford paper and a B pencil and I first sketched in very lightly the different blocks of buildings and the central bridge. When this seemed about right I drew the buildings in a little more strongly but with not too much detail. I had decided I would like to use pen-work with this watercolour and I could indicate the actual detail of windows and boats and figures to better effect with the pen. I was using my old fountain pen again and a mixture of colour of Burnt Sienna, fed into the pen with a brush. I drew lightly in pencil, some of the reflections in the water. Having completed the drawing work it was time to lay in the sky.

2. With a mixture of Burnt Umber and Ultramarine I ran in a grey wash, having first made the paper damp with a light wash of clear water. It was an ideal sunny cloudy day, and having painted the cloud formations, leaving areas of white, I dropped in some Raw Sienna in the middle section and then some Cobalt Blue in one or two places.

3. I ran the sky grey wash downwards over all buildings making the wash more brown by adding a bit more Burnt Umber, but keeping it all fluid from the sky down to the water's edge. I left certain areas white and un-painted such as the awning on the right and small areas of buildings on the left where walls were in sunlight. The various boats were included in this light brown wash.

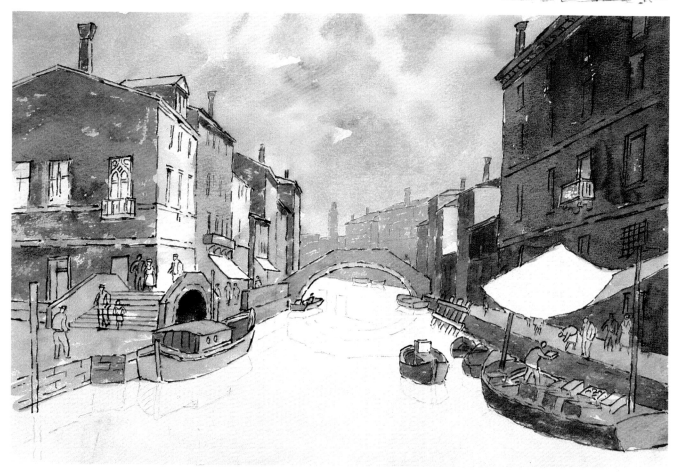

82 Stage 2

Figure 82, Stage 2

4. The distant buildings beyond the central bridge could now be painted a light grey using Cobalt Blue and Light Red. These buildings had not been inked in but were only in pencil.

5. The houses on the left had their shadow walls painted in with Burnt Sienna and Cobalt Blue giving a light grey-brown tone. The same colour was washed onto the further buildings on the right, and as these buildings come nearer I increased the colour to a darker tone changing the mixture to Burnt Umber and Ultramarine. This darker colour was used in the arch of the left-hand bridge.

Some of the boats were given a light brown shadow or two.

6. The central bridge was given a coat of dull pink using Light Red and a touch of Cobalt.

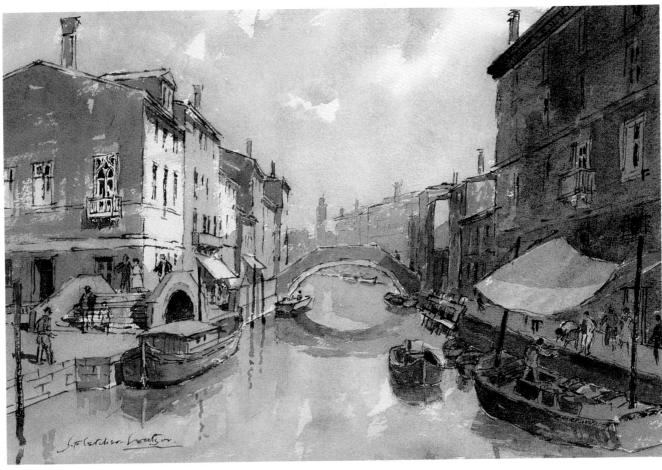

83 Stage 3

Figure 83, Stage 3

Now I could bring the picture to completion with some general strengthening and painting the reflections, and so on.

7. First the canvas awning over the fruit barge on the right received a toning down wash of grey with Ultramarine and a little Burnt Umber, and when dry I put on the shadow falling across it using the same two colours. The left-hand boat received the same colours again but with blue predominating. The other boats were painted in with more detail using Burnt Sienna and Cobalt. Figures were painted using those two colours again but varying the tone between blue and the red-brown of Burnt Sienna.

8. Now a lot of the windows received dark treatment of Burnt Sienna and Ultramarine, and shadows of figures and the bridge parapet on the left-hand side were put in with a small brush and those same two colours. Also various tall posts were painted dark brown.

With this subject I was conscious of the whole picture being rather monochrome in tone, and with the diffused sunlight there did not seem to be any outstanding reds or yellows on buildings.

9. Water reflections could now be painted in and first I did the sky reflection colours using the same greys and blues with which I painted the original sky. As this wash dried off I mixed a greenish colour with Payne's Grey and Raw Sienna. The Venetian canals always seem to have a rather green colouring whatever the day is like, sunny or cloudy. I painted in the reflections with this bluish-green, of boats, buildings and the central bridge and also the various posts. The picture was now coming to life well.

10. It needed one more item, namely the slanting shadow on the central bridge cast from the right-hand low buildings. This was rather a vital item.

I suddenly realised I had completed the picture and any more touchings up would only be fussing it unnecessarily.

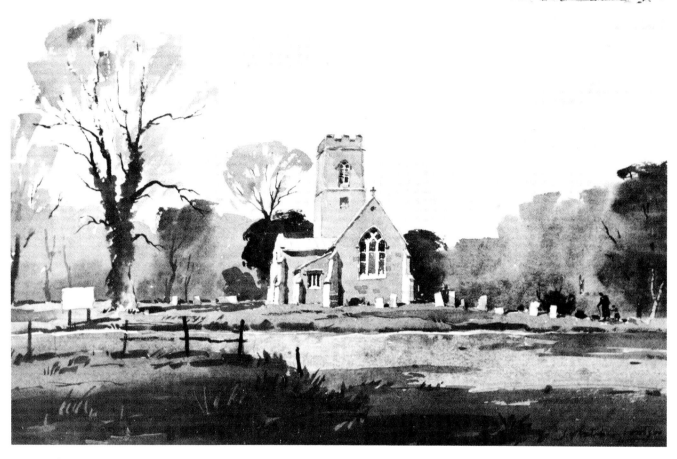

84 *Irstead church, Norfolk* 317 x 476 mm (12½ x 18¾ in)

This chapter on how to paint buildings is closely related to Chapter 3 and its advice on how to choose a subject, and my next few illustrations will dwell on finding a good building subject.

Once you have got beyond the stage of painting a simple barn or cottage, start looking for something with more architectural form about it and some interesting detail. I am always very intrigued by country churches so I will show you a good East Anglian church in Figure 84, *Irstead Church, Norfolk*. The features consist of the tower, the south transept with lead roof, the east end chancel gable with Early English pointed window, the buttresses with their interesting shapes, and the gravestones, themselves of considerable interest. All this is easy stuff to draw with a little practice, and look how well the whole building is set off with the dark trees close each side of it and the not-so-dark woods beyond.

The tall tree on the left gives a good counterbalance to the composition. The colour of the church was grey Norfolk flint-work which made a nice contrast to the green-brown trees.

111

Another Norfolk subject is St Benet's Abbey (Figure 85). This fascinating ruin stands on the marshes next to the River Bure and it is strange having a windmill (also a ruin) built right within the abbey. Here is an opportunity for you to draw some more Gothic detail and the open archway allows for a great feeling of depth into the shadows.

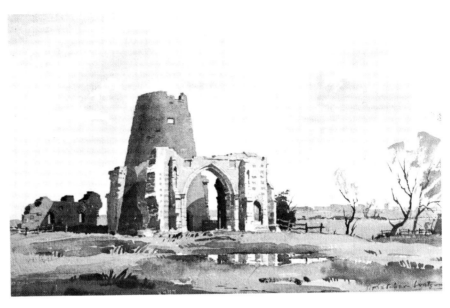

85 *St Benet's Abbey, Norfolk* 317 x 476 mm (12½ x 18¾ in)

86 *Castle Acre Priory, Norfolk* 305 x 489 mm (12 x 19¼ in)

Composition is so much the key to a good building subject.

Still in Norfolk we travel westward and find Castle Acre Priory (Figure 86). This is a delightful medley of Gothic and Tudor architecture with an interesting mixture of materials, brick, stone, flint and pan-tile roof.

There is plenty for you to draw in this picture and I used Barcham Green Pasteless Board paper, NOT surface: a lovely paper for watercolour. I had this picture in the Royal Academy Summer Exhibition of 1958; in those days they liked this sort of subject, but fashions seem to have changed. I think Cotman painted this subject from a different angle and he certainly painted the previous picture of St. Benet's Abbey, though in his day the windmill was working and his picture showed sails.

The left-hand Castle Acre building has rough flint walling, and when the grey wash of colour I painted was dry, I rubbed over it a stump of Conté crayon which produced a lot of little black marks coming off on the texture of the paper. This gave a rough flint effect rather well.

I strongly recommend Norfolk as a great county to explore to find building subjects to paint.

After this interlude of painting individual buildings let us return to considering how to paint towns or cities. We looked at this with the Venice picture, Figure 83, and I will take you again to Italy, and we will look at Figure 87 which is a panoramic view of Florence from Piazza Michelangelo. This piazza is at a high point overlooking the city and you see the river Arno curving away with a number of bridges, including the famous Ponte Vecchio with the houses built on it. It must be one of the loveliest views of a city in Europe, and in spite of its being rather daunting, I was longing to try my hand at it.

I chose an Arches NOT surface paper as being suitable for careful drawing as well as painting. This sort of subject is always a challenge and the great stand-by is to remember *simplification*. Half close your eyes and remember the message of Chapter 5 – distance, middle-distance and foreground. This view can be broken down into those three groups, but with a long distant view of this type one group merges into another and it all becomes a continuous process of stepping gradually back and back.

The composition was fairly easy with the river swinging down to the right from a central position, revolving round the medieval tower of the Palazzo Vecchio on the right which stands up above the whole city. The foreground trees and bushes to the left formed the perfect foil to the busyness of the hundreds of houses and roof tops and the bridges.

I started on the drawing using a B and an HB pencil, firmly drawing in the salient features such as the curve of the river's edge and the arches to the bridges and the more important houses, and then filling in the house and tree groups lightly and sketchily. I wanted this to be

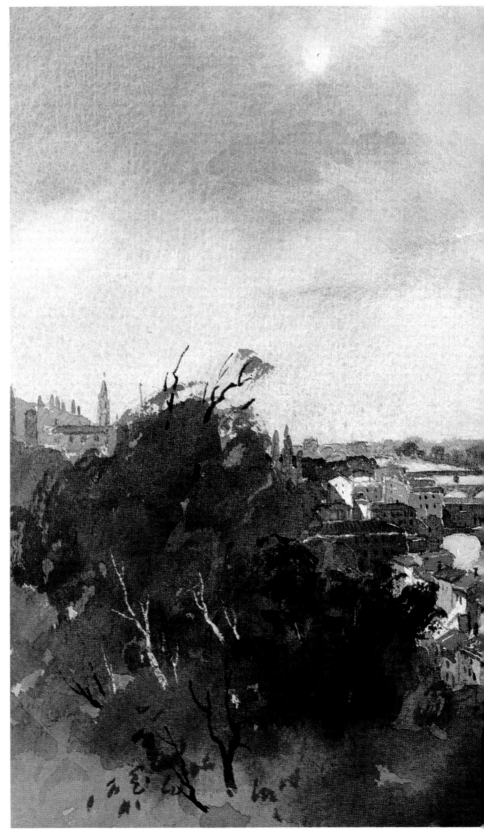

87 *Florence from Piazza Michelangelo* 317 x 476 mm (12½ x 18¾ in)

a full watercolour and not just a tinted drawing so it was important not to do *too much* drawing.

The first thing to be painted was, of course, the sky. It was the ideal sort of day with blue sky and sunshine but some useful

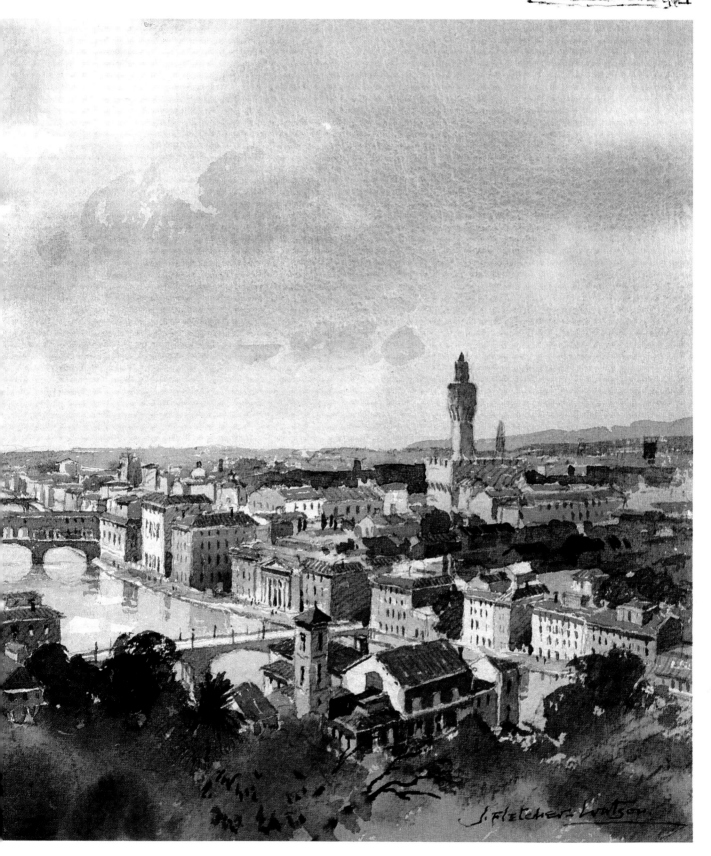

white clouds as well which were casting areas of the city into dark shadow. One certainly needed this to break up the monotony.

I used Ultramarine well diluted for the upper parts of the sky and added in a little Light Red as the wash came down to the horizon and also added in water to lighten the tone. A few grey clouds were put in using a mixture of these two colours.

The distant low hills were a mixture of these same two colours but a stiffer, less watery, mixture.

Now I added an all-over wash using a large brush and a mixture of Raw Sienna, Light Red and a touch of Cobalt. I did *not* include the river in this wash or some of the buildings which had almost white walls.

Next I could paint the shadow sides of houses, using the same three colours but more Cobalt Blue than before. Then I could add the many red roofs, which were largely Burnt Sienna varied by touches of Cobalt and an occasional Light Red. All this painting was made lighter in tone as the buildings receded into the distance.

Window details and eaves' shadows etc. were added with a small brush and a dark brown colour and the bridges were painted in with not too much detail; they were mostly in shadow being seen against the sun.

I could now tackle the foreground foliage using Raw Sienna, Winsor Blue and touches of Burnt Umber, making some trees quite dark where cloud shadows came over them.

The river was next painted using Cobalt and Light Red, and reflections were touched in.

Finally cloud shadows over the city were washed in with a medium size of brush, about a No. 6, using Cobalt and Light Red again for this. It had the effect of pulling the whole picture together.

Only seven colours were used – Raw Sienna, Burnt Sienna, Burnt Umber, Light Red, Cobalt Blue, French Ultramarine and Winsor Blue.

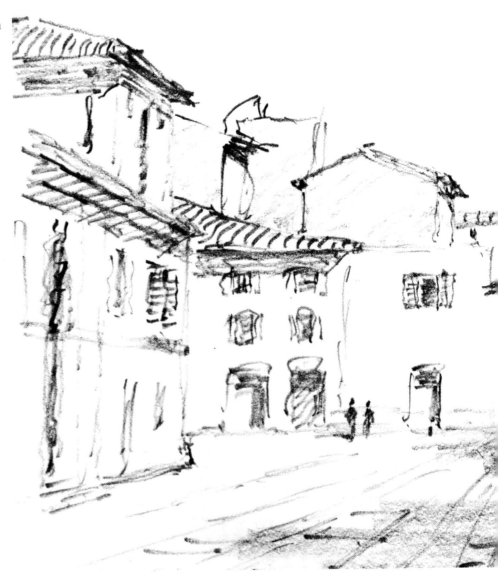

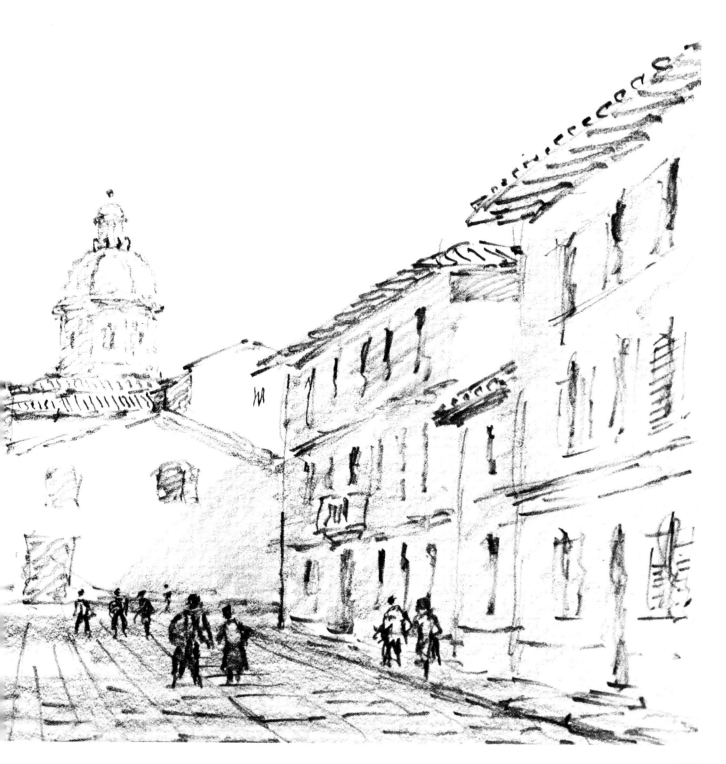

Florence is full of subjects to paint and an irresistible one is the Ponte Vecchio (Figure 88). This is the most ancient of all the bridges over the Arno and the little shops and houses built onto it make it the most unique structure. Some of the buildings actually overhang the water and are supported by wooden posts forming brackets coming out from the main wall of the bridge.

Much of the walling of houses above the stonework of the bridge are rendered and colour washed and the whole colour scheme is a mellow mixture of Raw Sienna and Burnt Umber, toned down with a little Cobalt Blue. The Roman tile roofs are a pinkish red and I used Burnt Sienna with some Cobalt for these. I used Arches NOT surface paper again and quite a firm pencil line with a B and 2B. This sort of subject requires careful drawing so that the curve of the arches is right and the proportion of the houses correct. And I lightly sketched in the reflections as it was important that they were right too. Almost most important of all is to have good strong shadows as the Italian light does give beautifully crisp shadows on buildings.

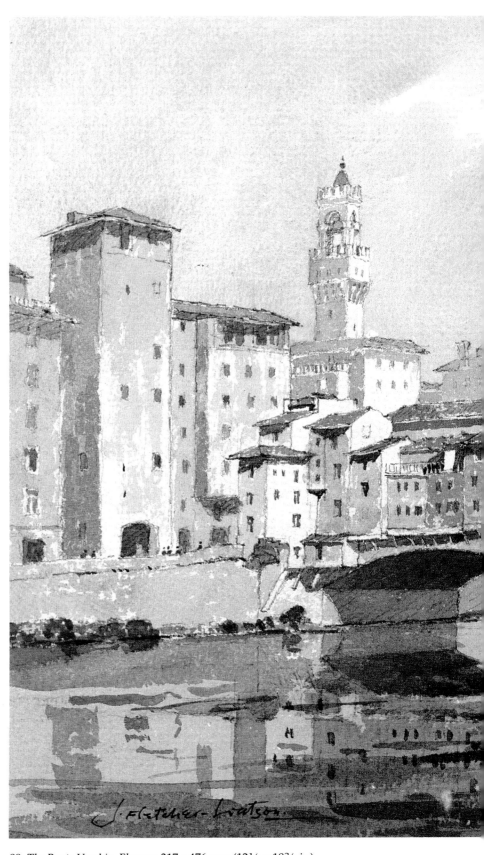

88 *The Ponte Vecchio, Florence* 317 x 476 mm (12½ x 18¾ in)

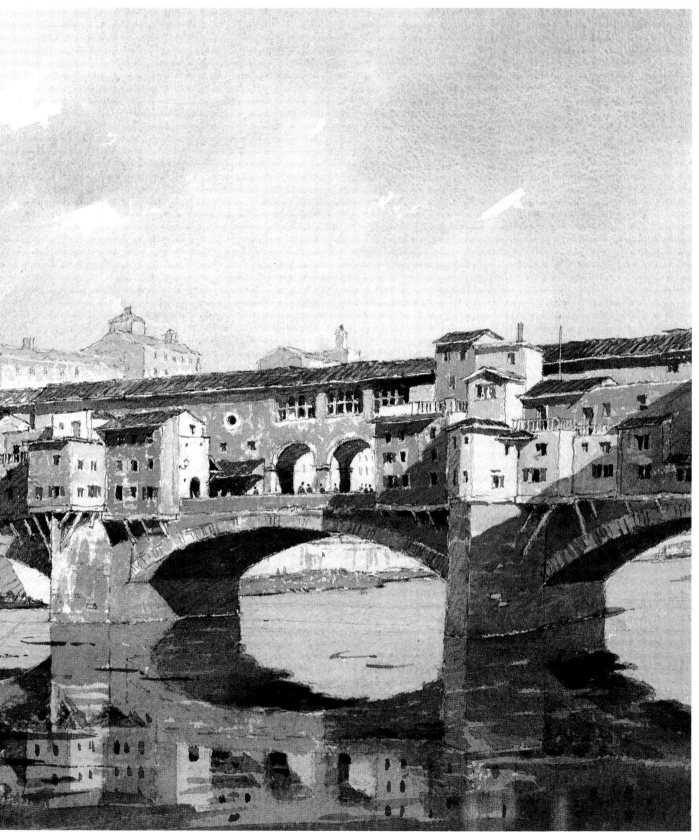

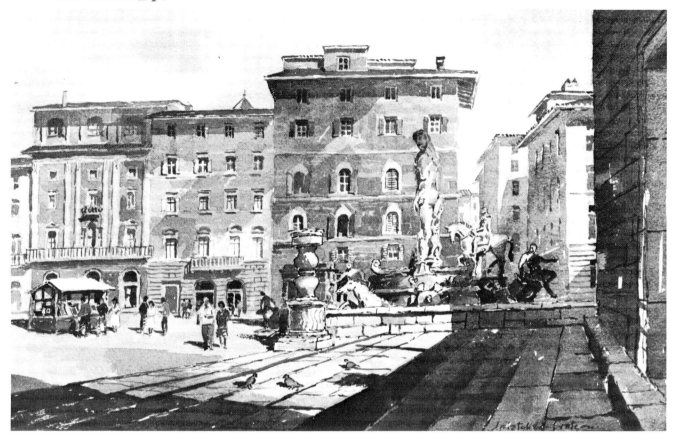

89 *Piazza della Signoria, Florence* 317 x 476 mm (12½ x 18¾ in)

One more Florentine view I would like to show you, as it is an example of being in the middle of a town with people moving about and a general feeling of activity, is of the Piazza della Signoria (Figure 89). It is also an example of very little pencil work being used. I drew the main outlines in light pencil on Whatman NOT surface paper, and then drew in details of roofs and windows and stone jointing and steps etc. with a small brush and a dark brown mixture of colour. Artists like Bonington became expert at this technique and deserve much study. You will notice that there are cloud shadows on some of the buildings and this can be a very attractive feature of a building subject when there are clouds as well as sun. Also notice the disposition of figure groups which get smaller as they go away from you, thus giving added perspective. Always make sure your figures are small enough to be able to go through doorways.

90 *Siena, Italy* 203 x 280 mm (8 x 11 in)

Now let us look at the beautiful old Italian hill town of Siena in Tuscany (Figure 90). This is a quick pencil sketch with a wash or two of Raw Sienna and Burnt Umber applied to the buildings and a little of Payne's Grey for the sky. It is the type of sketch I can one day do a nice watercolour from in the studio. Once you have made even a rough drawing of a place taking only about half an hour, the colouring is impressed on your mind's eye and it all comes back to you even two or three years later. You can remember the red roof, the yellow or white walls, the dark windows and the brownish green tree groups.

121

91 *The Leaning Tower of Pisa* 203 x 280 mm (8 x 11 in)

While we are in Tuscany we will take a look at another quick sketch, this time at Pisa. I made this little note of the Leaning Tower of Pisa (Figure 91) in pencil and wash again and it is really rather fun to draw this amazing structure with its leaning overhang of no less than 4 metres (13 ft)! We are told that the foundations gave way during the original building operation in 1172, so it has stood like this for over 800 years.

Pisa Cathedral stands close next door, and together with a small part of the city buildings to the right this view makes an interesting picture and would undoubtedly make a good watercolour at a later date.

I have not said anything about painting *interiors* of buildings, and for those of you who may be looking for an architectural subject on a day that is too cold or wet to go out of doors, there is always a subject or two for you to try within your own home. A bedroom with dressing table, a hall with staircase or a sitting room with desk and other furniture can all make a delightful picture. I have made many pictures of such subjects, but I also like painting interiors of churches.

92 *St Stephen Walbrook, under restoration* 359 x 330 mm (14 x 13 in)

I was commissioned recently to paint the interior of the Church of St Stephen Walbrook in London (Figure 92) and I found it a fascinating subject and rather a challenging one. To start with, the perspective of a dome carried on arches supported in turn on eight columns forming an octagon on plan, was not the easiest thing in the world to draw. But by drawing some light pencil guidelines to start with and then with a heavier line showing more detail, the picture took shape more easily than I thought it would. I added some pen work to some of the foreground details and finally added washes of watercolour. The tones were variations of Raw Sienna, Burnt Sienna, Burnt Umber and Cobalt Blue.

Another of the challenges was coping with noise and dust. The small mechanical digger and the pneumatic drill were making a

deafening noise and the foreman of the works lent me a padded ear headpiece. The dust from cement and rubble was excessive and I made a mask with my handkerchief.

The extensive restoration work was largely due to the underground Walbrook stream and its shifting banks, which led to settlements of the building and resulted in structural faults to wall and columns and so on.

The church council had my picture reproduced to make coloured greetings cards which they are selling in aid of funds to pay for the work.

I would certainly recommend my readers to try painting interiors of churches, preferably starting with a simple Gothic country church and leaving tackling one of Wren's city churches full of classical detail until they have become fairly experienced with their perspective.

Having said that I must hastily add that landscape subjects which include buildings of a great many varieties are not on the whole at all difficult, and it all comes easily in the end with lots of practice drawing in sketch books. My main object in this chapter is to help you over the *exteriors* of buildings in a landscape.

And my main object in this whole book has been to help all my many watercolour painting friends and others to paint better pictures of the hundreds of lovely landscape subjects that abound in the world. Remember always that painting watercolours means using plenty of water, letting it run over the paper with washes of transparent colour, controlling it and making it work for you as you want it to by giving the impression and suggestion of the scene without having to put in too much detail. Strive to produce the atmosphere and mood of nature and you will produce the magic of watercolour.

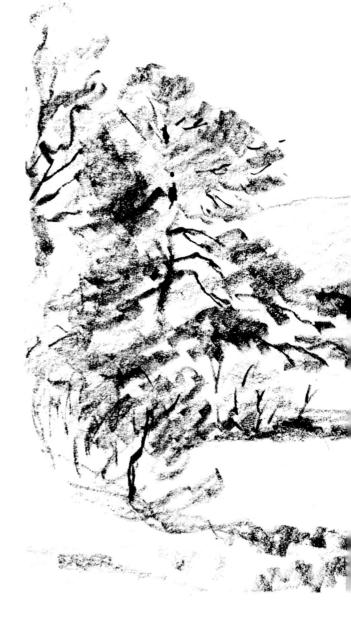

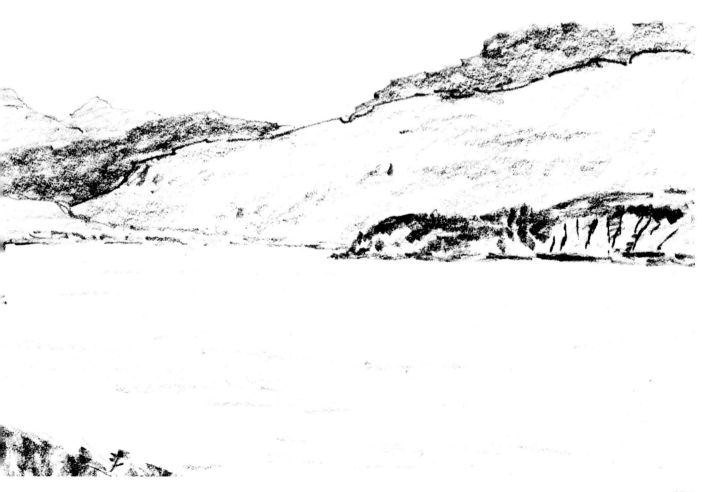

Water-Colour Painting: Landscapes and Townscapes

This practical book introduces the reader to the simple techniques and processes necessary to produce effective watercolour paintings, from preliminary drawings and rough sketches to painting straight onto the paper. The emphasis throughout is on painting out in the open, directly from nature.

Coping with a vast range of colours can be daunting for a beginner, and so the author gives instructions for painting effective pictures by limiting the colour choice to three, and then ten, colours.

This first book by the artist is aimed at those who have just started using watercolour, whether amateur or professional.

First published in 1982; reprinted in 1982, 1983, 1985 and 1986

First published in paperback in 1990

"It is essentially a book of advice and encouragement for the beginner from a sympathetic practitioner with long years of practical experience"

Arts Review

Subject and Place for Watercolour Landscapes

This second watercolour book answers the many questions from amateur artists concerning the choice of subject and location for watercolour landscapes.

Choosing locations in Norfolk, the Cotswolds, Venice and France, amongst others, James Fletcher-Watson describes the techniques required to capture widely differing scenes and moods. Within each subject description the author discusses composition, drawing and painting, and the art of capturing the essence of the scene.

Addressed mainly to the painter who has already made some progress with watercolours, but with much to commend it to the beginner also, this book deals clearly and methodically with the construction of paintings of a variety of landscape forms.

Published in 1985.

The Magic of Watercolour Video

A video called *The Magic of Watercolour with James Fletcher-Watson* is available and can be ordered direct from the artist at:

Windrush House
Windrush
Near Burford
OXFORD
OX8 4TU